IMAGES
of America

EDGEWOOD

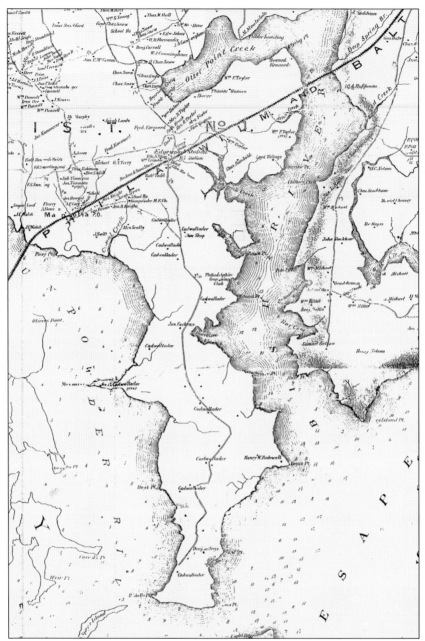

This 1878 map provides a wonderful overview of the Gunpowder Neck, formed by the Chesapeake Bay and the Gunpowder and Bush Rivers. Edgewood is located in the center, just north of the Philadelphia, Wilmington & Baltimore Railroad line. Note that most of the property south of the railroad was owned by Gen. George Cadwalader. (Courtesy of US Army.)

ON THE COVER: The Pennsylvania Railroad's 1942 Edgewood Station, with its sleek, modern design, accommodated the large volume of people coming and going to the nearby military base, Edgewood Arsenal. *Time* magazine and *Architectural Forum* hailed the horizontally oriented, one-story building for its modern design and distinction from other stations of the day. (Courtesy of Hagley Library and Museum.)

IMAGES
of America

EDGEWOOD

Joseph F. Murray, Arthur K. Stuempfle,
and Amy L. Stuempfle

ARCADIA
PUBLISHING

Published by Arcadia Publishing
Charleston, South Carolina

Printed in the United States of America

Library of Congress Control Number: 2012932762

For all general information, please contact Arcadia Publishing:
Telephone 843-853-2070
Fax 843-853-0044
E-mail sales@arcadiapublishing.com
For customer service and orders:
Toll-Free 1-888-313-2665

Visit us on the Internet at www.arcadiapublishing.com

This book is dedicated to Margaret E. Stuempfle and Katherine C. Stuempfle. Their two grandfathers and mother undertook this project so they would know more about their hometown.

CONTENTS

Acknowledgments

This book could not have been written if it were not for June Hanson. Without her, much of the community of Edgewood's history would have been lost. As the editor of the "In and Around Edgewood" section of the now-defunct *Harford Democrat* during the 1970s and early 1980s, she single-handedly captured the pulse of virtually all phases of everyday life in Edgewood, including the history of things. She also had a "Fun Flights" section in which she showed aerial photographs she had taken over Harford County. These photographs provide unique overviews of Edgewood. We are extremely grateful that her son, Stephen E. Hanson, agreed to our request to provide Mrs. Hanson's original pictures and copies of those old newspaper sections to the Edgewood Branch of the Harford County Library so that we could use these wonderful resources for the book. Mrs. Hanson was also instrumental in getting older Edgewood residents to provide oral histories about their lives and experiences to the Harford County Library. Those too were wonderful resources in researching this book. We want to thank the head librarian at the Edgewood Branch Library, Susan Deeney, for all her assistance in this matter. Throughout the rest of the book, we refer to the Harford County Public Library as HCPL.

The source for images and information concerning the impact of the military's presence in Edgewood was Jeffery K. Smart, command historian, US Army Research, Development and Engineering Command, Aberdeen Proving Ground, Maryland. All images credited as "Courtesy of US Army" came from his office. We are particularly thankful for his guidance and subject-matter expertise and for the technical support provided by William H. Hauver, program support assistant on his staff.

The rest of the book consists of photographs provided by local residents who wanted to see Edgewood's heritage preserved. We apologize that we could not include all of their submissions. The Edgewood Community Council's support in letting people know about our project and soliciting their help throughout this endeavor was definitely appreciated. We also want to thank our Arcadia editor, Brinkley Gary, for her expert assistance.

INTRODUCTION

Edgewood, Maryland, is located in southeastern Harford County, in an area once known as the Gunpowder Neck. Its history is filled with many interesting highlights. For example, the origins of the early Methodist church in America can be traced here. The rich and famous used to come to the area to enjoy its fabulous hunt clubs. During World War I, Edgewood Arsenal became the epicenter for US chemical warfare research, testing, and manufacturing. Edgewood was once the home of a nationally recognized motorcycle raceway. Edgewood's Flying Point Park was the county's first public beach. This book traces the history of Edgewood from its earlier days through the 1970s.

Edgewood is situated in the top center of an inverted triangular peninsula created by the Chesapeake Bay to the south, the Gunpowder River to the west, and the Bush River to the east. Capt. John Smith explored the Bush River and in fact named it Willowbyes Flu, after his home town. Long before Thomas O'Daniel, the first white settler, arrived on Gunpowder Neck, Native Americans lived near a spring in Edgewood. In 1732, the Presbury Meeting House was established as one of the first Methodist churches in America.

A railroad line built through the area in 1835 provided an outlet for the local agricultural economy, and in the mid-1800s, the train station provided the seed for Edgewood's development. The station was located an equal distance from the Gunpowder and Bush Rivers.

Although the population of Edgewood was only 30 in 1878, the adjacent countryside's fertile farmland contributed to the local population. This area had handsome residences, many erected by gentlemen commuting daily to Baltimore via accommodation trains. Edgewood had a schoolhouse, post office, express office, hotel, general store, and blacksmith. It was connected to the town of Bel Air by a good road over which stagecoaches passed twice a day.

The Edgewood station derived added importance because of its proximity to the favorite hunting grounds for waterfowl that annually migrated in immense numbers to this vicinity. The birds ate wild celery and other marine plants produced in the shallow waters of the Bush River and its tributaries, which gave them a rare flavor so inviting and pleasant to the palate of the epicure. Gentlemen sportsmen from Baltimore, Philadelphia, and other cities as far north as Boston came here to hunt.

According to one account, Edgewood station received its name from Edgewood, the nearby summer home of Maj. Gen. Isaac Trimble, who was superintendent of the Philadelphia, Wilmington & Baltimore Railroad. Another source suggests that perhaps the village derived its name from being at the edge of Gen. George Cadwalader's domain. Cadwalader, a war hero, Philadelphia lawyer associated with many medical societies, bon vivant, and subsequent president of the Baltimore & Philadelphia Steamboat Company, gradually acquired a paradise consisting of about 8,000 acres on Gunpowder Neck and invited rich and powerful friends to visit. He leased some waterfront sections to hunt clubs of wealthy sportsmen. Cadwalader also had 16 different farms on the property, and tenant farmers paid Cadwalader a certain percentage of their crop.

Another dominant personality in Edgewood's early history was Herman W. "Boss" Hanson. He was a prosperous gentleman farmer, a member of the Maryland House of Delegates for 12 years, and a very astute businessman. It was said at the time that if you didn't work for the railroad, you worked for "Boss" Hanson. Tomatoes were the cash crop, and at one point, Hanson was involved in operating four canneries in the area and bought all the other local farmers' tomatoes. The canned tomatoes were typically sold under the name of Queen Brand. The Queen Brand had a green label with a big red tomato on it. Hanson shipped canned tomatoes all over the country and even transported some overseas.

Two miles down the tracks from Edgewood station was the Magnolia station. This area got its name from the beautiful and fragrant magnolia trees that grew there. Opposite the station was Magnolia Grove, a favorite resort for picnics and excursion parties from Baltimore. A spacious circular pavilion in the grove was used for festive dances. By the early 1900s, Magnolia also had a church, two-room schoolhouse, post office, blacksmith shop, canning house, general store, shoe shop, and barbershop.

The bucolic life of those living in and around Edgewood changed dramatically in October 1917, when the US government took possession of all of the land south of the railroad tracks on Gunpowder Neck to create the Edgewood Arsenal military complex. At the time, the population of the village of Edgewood was less than 100 people. Thousands of people came to construct numerous facilities to handle the various aspects of chemical weaponry. The government built plants to produce such toxic chemicals as mustard gas, chlorine, chloropicrin, and phosgene. They even produced gas masks for horses at the arsenal. Peak employment during July 1918 totaled 8,542 civilians and 7,475 military personnel.

While people like General Cadwalader were paid for their property, the tenant farmers and sharecroppers received nothing. A number of such black farmers relocated to create a small community of very small homes in the Magnolia area that was called Denbytown.

In October 1922, the War Department decided it needed a field artillery range and took a large section of the Edgewood Arsenal to create Fort Hoyle, named in honor of Gen. Eli D. Hoyle, who had died just a few weeks earlier. Magnolia became the gateway for Fort Hoyle. The ground used for Fort Hoyle was returned to the Edgewood Arsenal in September 1940, having been the last home for a horse-drawn artillery unit.

The military presence changed everything in Edgewood. For example, in the 1920s, the military and Harford County officials agreed to jointly provide schooling for all children. World War II brought a new wave of military personnel and civilians to Edgewood. The arsenal brought people from all over the country to this somewhat remote rural location. A new and modern train station was built to handle the great influx of people. Civilian dormitories and off-post housing units were constructed in various Edgewood locations. This influx of people, coupled with the completion of Route 40, a four-lane highway through Edgewood, spurred and shifted economic development. Motels and restaurants opened. Tourists came. Shopping centers and a wide variety of businesses were built. In 1963, the Edgewood exit on Interstate 95 opened, spawning even greater numbers of residential neighborhoods.

This book is designed to give some insight and perspective to many aspects of Edgewood's history: its humble beginnings; the changes brought about by the military presence; the development of neighborhoods; the various public, civic, and religious focal points that help create this vibrant community; the enterprises that spurred its commercial growth; and the cornucopia of things that have made living in Edgewood fun.

One

HUMBLE BEGINNINGS

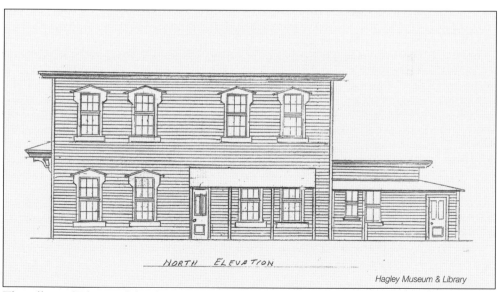

NORTH ELEVATION

Hagley Museum & Library

The village of Edgewood developed around the train station on the Philadelphia, Wilmington & Baltimore Railroad. The early station was a two-story, rectangular frame combination passenger station and agent's dwelling. An 1877 railroad guide stated that the station derived added importance because of its proximity to the favorite feeding grounds of the waterfowls that attracted many duck-hunting gentlemen from major East Coast cities. (Courtesy of Hagley Museum and Library.)

Long before the village was established, a good-sized Indian community resided in the Edgewood area. Numerous arrowheads and other Indian relics were found near this spring, which flowed from between these rocks beside Brown Street in the Edgewood Heights area, south of Trimble Road. (Photograph by June Hanson; courtesy of HCPL.)

The marker indicates that in 1608, Capt. John Smith explored what is now called the Bush River. He named it Willowbyes Flu after his home in England. This may explain how Edgewood's Willoughby Beach Road got its name. (Photograph by June Hanson; courtesy of HCPL.)

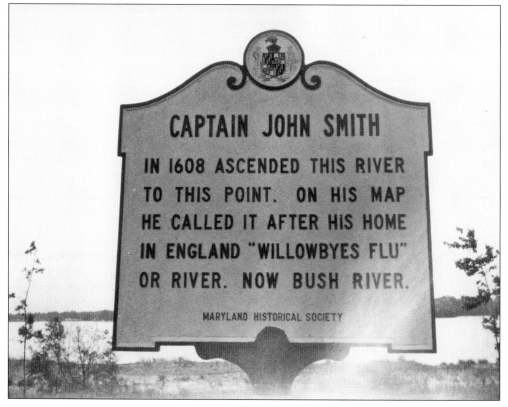

CAPTAIN JOHN SMITH

IN 1608 ASCENDED THIS RIVER TO THIS POINT. ON HIS MAP HE CALLED IT AFTER HIS HOME IN ENGLAND "WILLOWBYES FLU" OR RIVER. NOW BUSH RIVER.

MARYLAND HISTORICAL SOCIETY

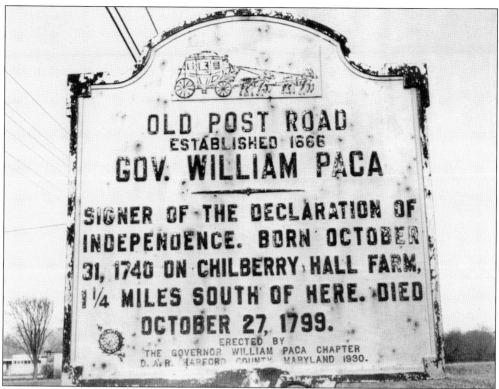

As this old marker indicates, Old Post Road was created in 1666. From its earliest days, this road was the principal route for people traveling between northern and southern colonies and going to and from the Gunpowder Neck area. It was also the main road for local farmers moving their goods to market. It became known as Philadelphia Road and subsequently Maryland Route 7. (Photograph by June Hanson; courtesy of HCPL.)

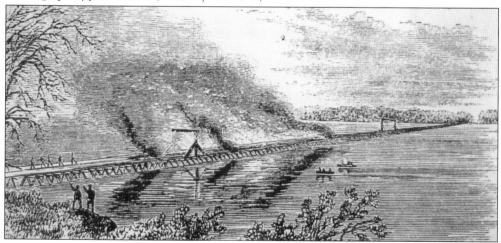

The Gunpowder River wooden railroad bridge was burned in April 1861 following the Baltimore riots. The bridge was burned a second time in July 1864, when Confederate major Harry Gilmor captured two trains and set one on fire and sent it out onto the wooden bridge (as shown). The old bridge was located very close to where the current railroad bridge stands. (Courtesy of US Army.)

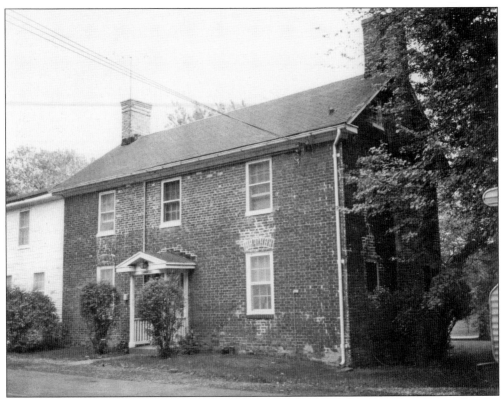

Quiet Lodge, James Presbury's home, was built around 1720. It was later closely connected to the start of the Methodist Church in America. Early Methodist preachers frequently mentioned it in their journals, and America's first Methodist bishop stayed here more than a dozen times. After the military took it over in 1917, it was used as an officer's quarters. It was declared a national historic site in 1974. (Photograph by June Hanson; courtesy of HCPL.)

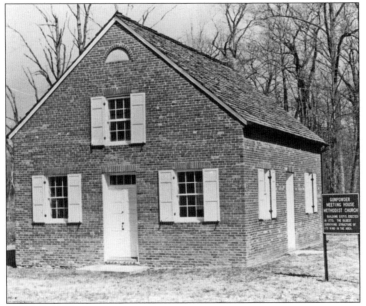

Joseph Presbury, a descendant of James Presbury, had the Gunpowder Meeting House built around 1773. The Methodist congregation actively used it until about 1886. The Negro Methodist Episcopal Church bought it in 1890 and used it as a church and school until 1917, when the military took over the property. The military used it to store grenades before it was preserved as a historic site. (Courtesy of US Army.)

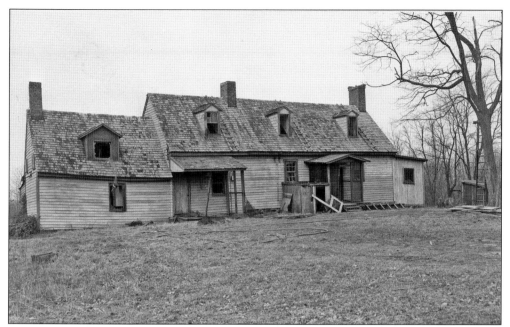

For 200 years, the Maxwell-Day house sat on a small peninsula that jutted out into the Gunpowder River. Once considered the oldest existing dwelling in Harford County, it was likely built shortly after James Maxwell gave 514 acres, known as Maxwell's Conclusion, to his daughter Phillipa and her new husband, John Day. Gen. George Cadwalader bought the property in 1848. (Courtesy of US Army.)

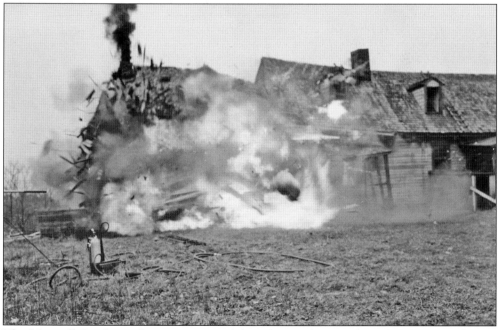

The Maxwell-Day house became a part of the Edgewood Arsenal in 1917. In 1943, the US Army destroyed the structure during a World War II experimental firebombing. (Courtesy of US Army.)

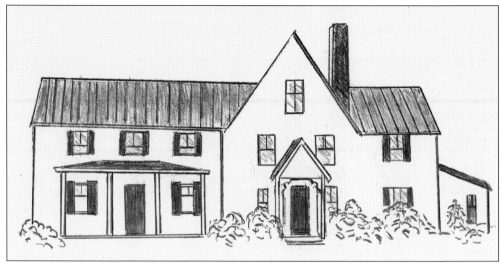

Edgewood Farm was Maj. Gen. Isaac Trimble's home. Built in the first half of the 1800s, the big white house on the hill was a landmark to train travelers. Some assert that the community took its name from that of Trimble's farm. The sketch shows how the home looked in 1940. In October 1969, the house was destroyed by fire. (Courtesy of Joseph Murray.)

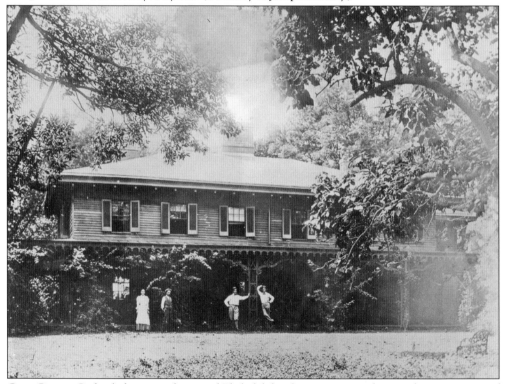

Gen. George Cadwalader, a war hero and Philadelphia lawyer, acquired a paradise consisting of thousands of acres near Edgewood and invited rich and powerful friends, such as Grover Cleveland and Daniel Webster, to visit. While Cadwalader's 20-room mansion was luxurious, his estate was more famous for its hunting preserves and arboretum. The Army demolished this mansion in the 1920s. (Courtesy of US Army.)

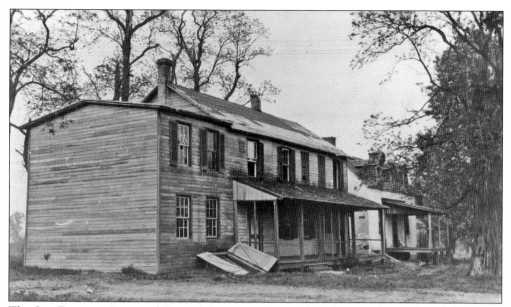

The San Domingo Farm and Gun Club, seen in this c. 1919 photograph, was leased from John Cadwalader, who had inherited the Gunpowder Neck property from his uncle, Gen. George Cadwalader. One of the largest and best such gunning clubs, San Domingo attracted some of America's richest gentlemen hunters. (Courtesy of US Army.)

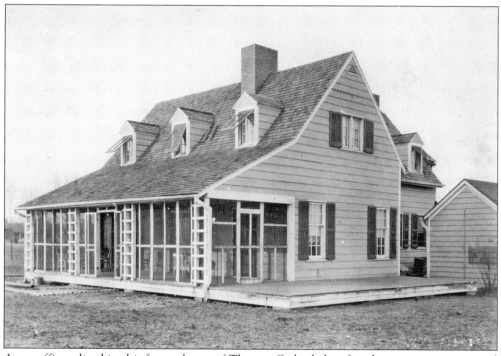

Army officers lived in this former home of Thomas Cadwalader after the government acquired the property in 1917. This photograph was taken around 1920. (Courtesy of US Army.)

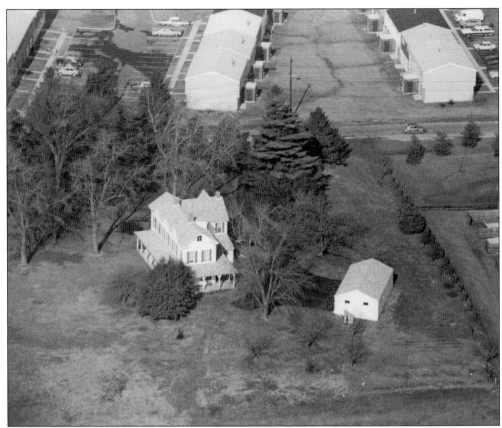

In this 1974 photograph, the Thomas Hanson home is the single-family dwelling on the center left, surrounded by Seven Oaks Apartments along Hanson Road, at the top, and some of the Harford Square townhouses on the right. This mansion, built in the early 1800s, has 51 windows and seven gables. It was the first home in Edgewood to have indoor running water. A windmill was used to pump water into a huge holding tank on the third floor. The property was passed on to Thomas Hanson's son, Herman "Boss" Hanson, and then on to his son, Thomas Earl Hanson. Below is a photograph of the Hanson barn just before it was burned down by local volunteer fire companies in 1972 to make room for more housing in the Harford Square development. (Photographs by June Hanson; courtesy of HCPL.)

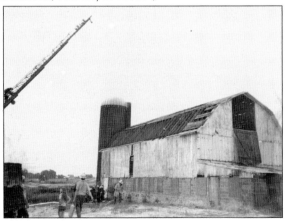

16

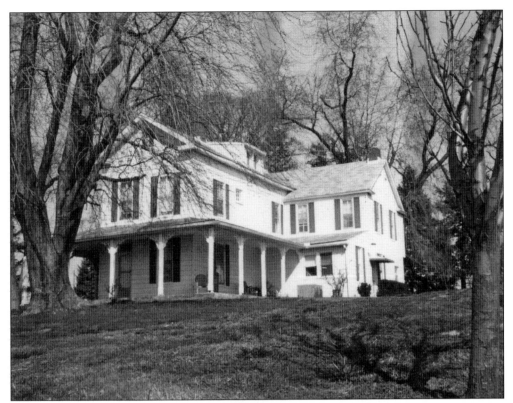

This 1974 photograph shows the south and east sides of the Thomas Hanson home. The kitchen wing was not original to the building but was added in the 1800s. The framing lumber came from old slave quarters that had been torn down. The house sits atop a hill, and the farm was called Seneca Ridge. It was said that on a clear day one could see across the Chesapeake Bay to the Eastern Shore. (Photograph by June Hanson; courtesy of HCPL.)

This is one side of a double-sided fireplace in the Thomas Hanson house's living room. Each room contained a Latrobe stove that heated the downstairs plus the upstairs through a system of registers. The large portrait over the mantel is of Herman Hanson, Thomas Hanson's only son. The other pictures on the mantel show four generations of Hansons. (Photograph by June Hanson; courtesy of HCPL.)

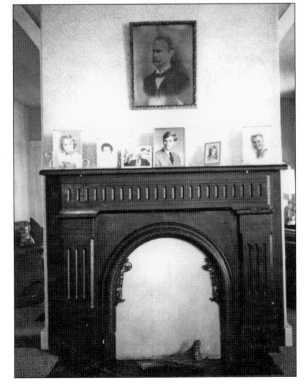

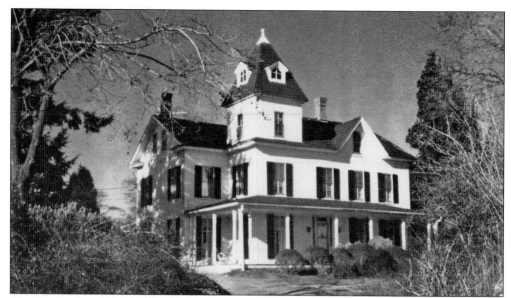

The Victorian Lady was originally the home of the Lantz family. The original three-story portion of the home, which is to the right of the tower, was built around 1853. The tower and all behind and to the left of it were added in 1899. (Photograph by June Hanson; courtesy of HCPL.)

Irene Myers (shown here at her 90th birthday party in 1979) and her husband, Fred, moved to the Victorian Lady in 1918, when they had to vacate their farm because of the government takeover. They bought the house from Lucy Lantz, Myers's aunt (sister of Herman "Boss" Hanson). Hanson and Lantz were well-known names in the canning business. Myers lived in the Victorian Lady for most of the 20th century. (Photograph by June Hanson; courtesy of HCPL.)

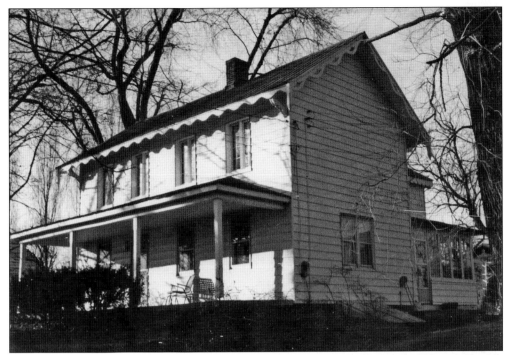

The Emmord Hanson farmhouse on Trimble Road was constructed around 1800 with French windows. The house has hand-hewn log framing, originally covered with vertical siding, then German siding, and finally white aluminum siding as shown in this 1974 photograph. Several other changes were made over the years. (Photograph by June Hanson; courtesy of HCPL.)

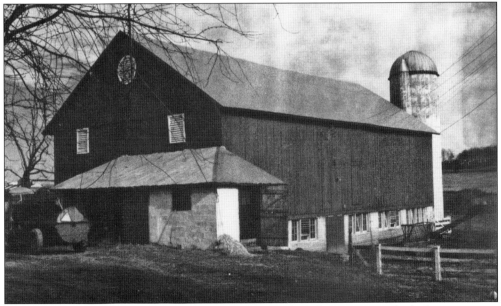

Emmord Hanson's "new" barn was built in 1892 by Frank Skillman, reportedly the best carpenter in Harford County at the time. It is 40 by 70 feet and covered with 16-foot-long, 12-inch-wide pine boards. It contains some boards that were in a smaller barn that was about 100 years old when it was taken down. (Photograph by June Hanson; courtesy of HCPL.)

Emmord Hanson and his wife, Mary, shown here, as well as his brother Thomas Earl Hanson and his sisters Irene Myers and Naomi Carmen, were recognized in 1981 as part of an elite group of "Harford Living Treasures." The oral histories of these octogenarians provide key insights into Edgewood's history. (Photograph by June Hanson; courtesy of HCPL.)

The springhouse on the Hanson farm on Trimble Road was constructed in the early 1800s. The 18-inch-thick walls were constructed of local stones. It was used primarily to keep milk cold. (The milk was stored in three- and five-gallon cans, which were then shipped to market.) The structure was used for this purpose until electricity came to the farm in the 1930s. (Photograph by June Hanson; courtesy of HCPL.)

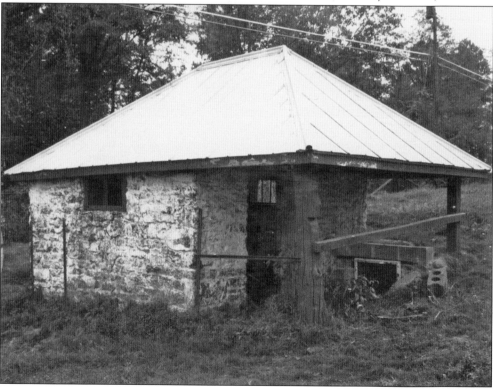

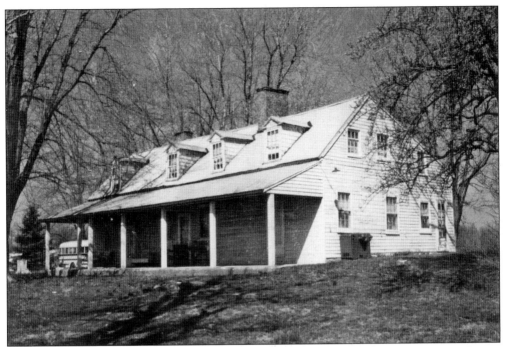

The Flottemesch home, which stood at the intersection of Hanson and Magnolia Roads, was reportedly built some time in the 1800s. According to the Maryland Inventory of Historic Properties, the house was about 25 feet wide and 45 feet deep. This is how it looked in 1974. It subsequently burned down. (Photograph by June Hanson; courtesy of HCPL.)

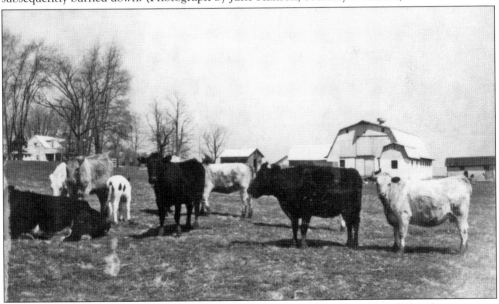

The background of this 1974 photograph reveals glimpses of the Flottemesch farmhouse, pump house, corn house, 65-foot-long dairy barn, milk house, and shed. The Flottemesch family operated a canning facility here from 1898 until 1919. They also once had a sawmill on the property. The beef cattle belonged to a farmer who had leased the property while it awaited future development. (Photograph by June Hanson; courtesy of HCPL.)

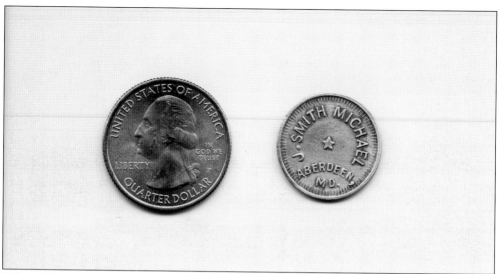

Tokens, like the one shown at right in the photograph, were typically used to pay the Bohemians who worked at various canneries in Harford County. The local stores would accept such tokens as payment and would get reimbursed by the cannery owners. (The quarter is included to show the relative size of the token.) (Courtesy of Bernard Bodt.)

The Timmons house, near the corner of Magnolia and Trimble Roads, was believed to have been built in the early to mid-1800s. The home's exterior was initially covered with vertical siding and later with cedar shingles. The home was occupied by the Godwin family in the 1890s. (Photograph by June Hanson; courtesy of HCPL.)

The Welzenbach family home was built in the mid-1800s. The original structure was the section to the right of the chimney to the gable end of the roof. The left end of the house, the one-story room on the right, and the dormers had been added more than 50 years before this 1974 picture. The enclosed porch along the front was a later addition. (Photograph by June Hanson; courtesy of HCPL.)

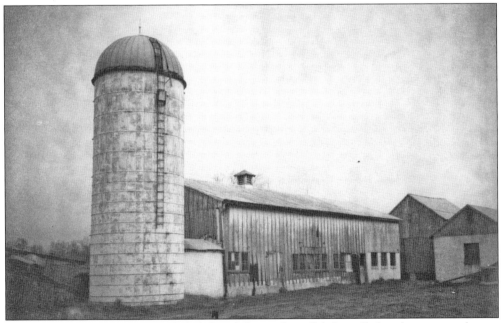

The Welzenbach family farm included, from left to right, a "Michigan" silo, a barn, a corn house, and a dairy barn. Originally, they shipped milk by train to Baltimore, but they began selling raw milk on the retail market from the early 1900s until 1968. During World War I, Edgewood Arsenal was one of their biggest customers. (Photograph by June Hanson; courtesy of HCPL.)

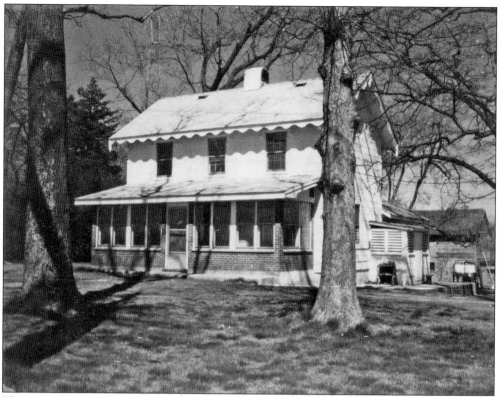

The original part of this farmhouse was built in the early 1800s. The Sweetings family is named as the owner on the Martenet map of 1878. According to Palmer Johnson, who bought the farm in 1940, it was named Friendship on the deed. (Photograph by June Hanson; courtesy of HCPL.)

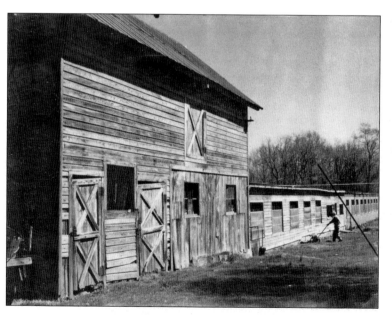

The barn on old Friendship Farm was built in the 1920s, and the chicken houses were added a few years later. Longtime residents of Edgewood will remember Palmer Johnson as "the Egg Man" who delivered eggs to homes for many years. (Photograph by June Hanson; courtesy of HCPL.)

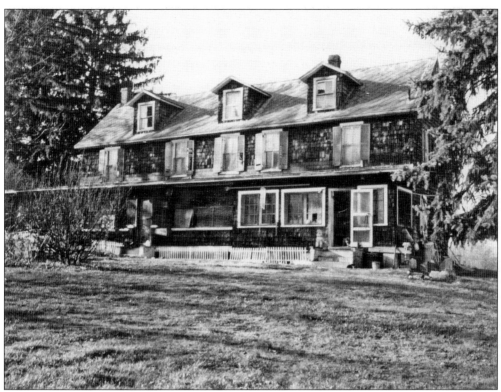

The old Woolford farmhouse was constructed in the mid-1800s. It was rented by the Bearsch family in the early 1900s. They moved away when Harry Skillman, one of a number of farmers displaced when the US government acquired his land for the Edgewood Arsenal, bought the property from an absentee owner from New York. (Others who had to move in 1917 because of the government takeover included Alec and John Frey, Fred and Will Myers, Ed Flottemesch, Tessie Skully, Will Bechtold, George Waltman, and several black families, including the Demby, Peters, Gilbert, Briley, and Peaker families.) The arched windows on the sides of the third floor were of architectural interest. In the 1970s, this three-story home was demolished to make way for the Willoughby Woods development. (Photographs by June Hanson; courtesy of HCPL.)

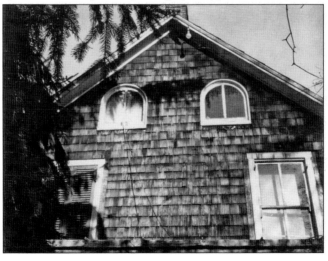

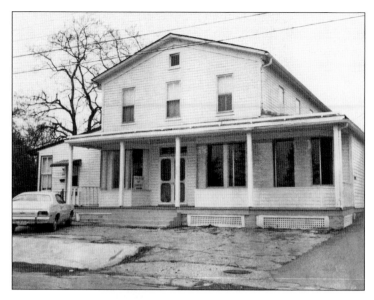

The Maryland Historical Trust considers this two-story, gable-front building located at 2118 Old Edgewood Road to be historically significant. This 19th-century store served as the commercial and social center of the Edgewood community. An 1878 map indicated that the Mechem and Sons store was located at approximately this site. (Photograph by June Hanson; courtesy of HCPL.)

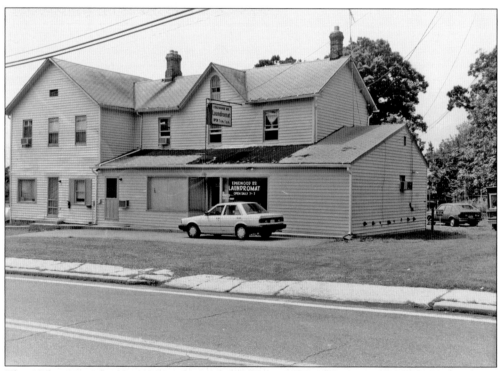

This 19th-century building, located at 106-108 Edgewood Road, is on the Maryland Inventory of Historic Properties. For much of its history, at least a portion of the building was used as a store. Between 1920 and 1941, the Edgewood Lodge 141 of the International Order of Odd Fellows owned it. In this 1970s photograph, the buildings were being used for apartments and a laundromat. (Courtesy of Maryland Historical Trust.)

The Edgewood Methodist Episcopal Church was built in 1898. Harlan Numbers, the appointed stationmaster for the Pennsylvania Railroad, donated money to start a church building fund and convinced a local company, Bartlett, Hayward and Tydings, to donate a half-acre of land for the church. (Photograph by June Hanson; courtesy of HCPL.)

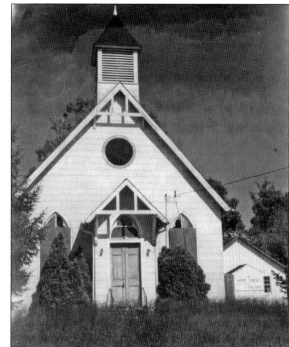

The old Edgewood Methodist Episcopal Church had not been in use for several years when it was intentionally burned down in August 1979 by local volunteer fire companies. (Courtesy of Linda Riley.)

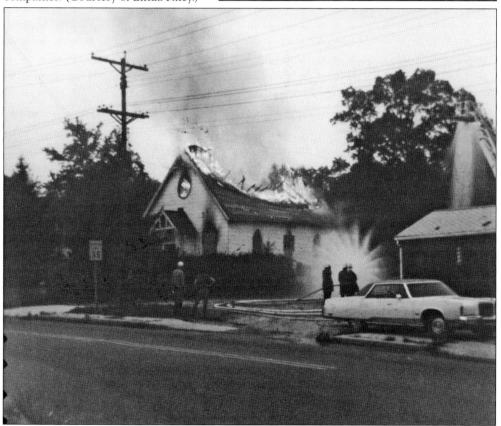

This house, located at 2120 Old Edgewood Road, formerly Railroad Avenue, is one of the earliest still-standing homes in Edgewood. Although an addition has been added to the back of the house, the front shows the straightforward, simple architectural design used in the early 19th century. The photograph was taken in 1974. (Courtesy of Linda Riley.)

Two miles down the tracks from the Edgewood station was the Magnolia station. Opposite the station was Magnolia Grove, a favorite resort for picnics and excursion parties from Baltimore. In the grove, a spacious, circular pavilion, measuring 75 feet in diameter, was used for festive dances. The pavilion was under an overarching canopy provided by the tall trees. (Courtesy of Margaret Stuempfle.)

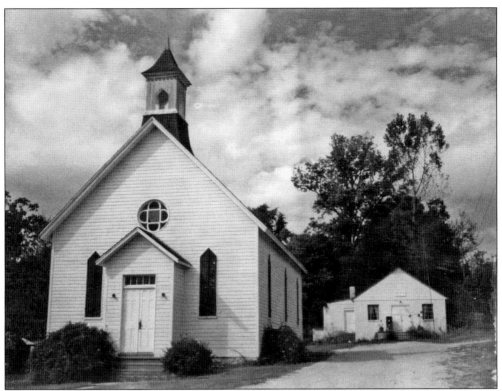

By the early 1900s, Magnolia, named for its beautiful magnolia trees, had a train station, post office, general store, church, two-room schoolhouse, blacksmith shop, canning house, shoe shop, and barbershop. John Sheridan built the Magnolia Methodist Episcopal Church in September 1888 on land donated by George C. Brown. After the congregation merged with other Methodists, the church was put up for sale in 1973. (Photograph by June Hanson; courtesy of HCPL.)

In 1970, the hall behind the Magnolia Methodist Episcopal Church became the Magnolia Post Office. The post office was started in April 1840 at the train station and was moved to the general store and then to this location. Subsequently, it was moved into a trailer at the end of Fort Hoyle Road. The Magnolia Post Office was discontinued in March 1994. (Photograph by June Hanson; courtesy of HCPL.)

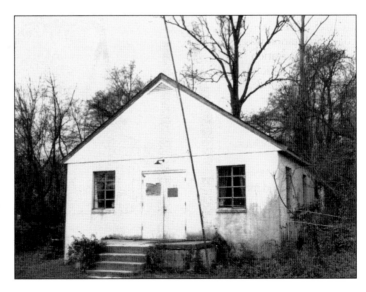

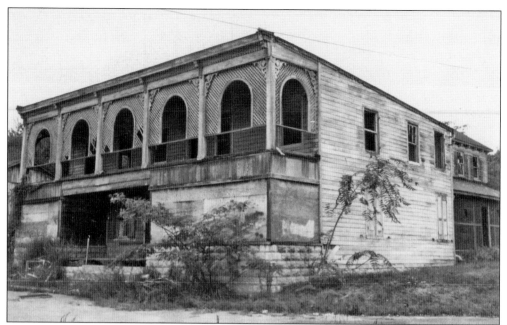

The Magnolia Store, known to locals as Brown's Store, was located across from the Magnolia train station. Edgewood residents frequented this general store for over 100 years. The large scale and use of decorative sawn brackets made this complex the most easily recognized and imposing building in Magnolia. It closed in 1970. This is how it looked in 1973. (Photograph by June Hanson; courtesy of HCPL.)

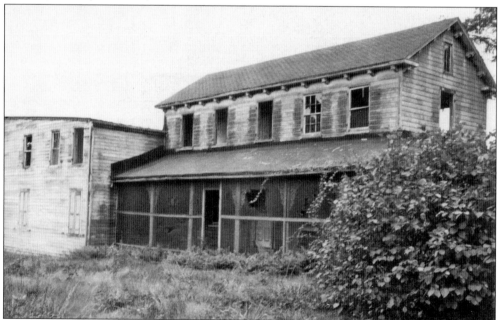

Brown's Store was a two-part complex—a house and a store that were connected to one another. The house portion of the complex was probably built in 1865. The store was perpendicular to the house, and one entered it through the living room of the house. (Photograph by June Hanson; courtesy of HCPL.)

The Brown family lived in the residence that adjoined the storefront. There were also bedrooms over the store, several opening onto the balcony at front. As shown here, the back porch of the Browns' home had fancy curlicues bracketing the tops of posts holding up the roof. (Photograph by June Hanson; courtesy of HCPL.)

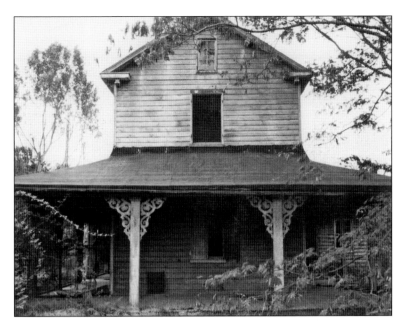

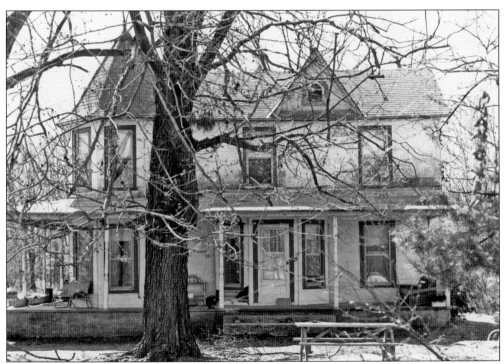

The Crouse-Kline House, on Magnolia Road, was built in 1918. According to the Maryland Historical Trust, this home's most distinguishing aspect is its orientation to the crossroads at the corner of Magnolia and Trimble Roads, providing "a strong visual anchor that reminds the passerby of the importance of this rural intersection." (Courtesy of Maryland Historical Trust.)

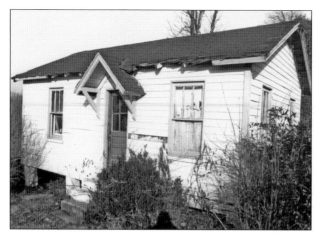

The Margaret Demby House, a small, two-room house, was one of a cluster of small residences in an area outside of Edgewood known as Dembytown. This community started in 1917. When the federal government took over thousands of acres for the Edgewood Arsenal, the workers, generally black tenant farmers or sharecroppers, had to relocate. A number of the displaced farmers purchased small parcels of land here. (Courtesy of Maryland Historical Trust.)

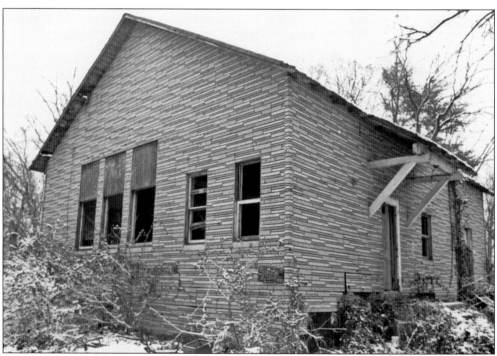

The Dembytown Schoolhouse, also known as the Magnolia Colored Schoolhouse, was built about 1920 and represented Harford County's early efforts to provide education for black children. The school was used until 1950. In 1951, the black children began attending the Central Consolidated School, located in Hickory. The Dembytown School was later converted into two apartments and covered with asbestos siding. It has since been demolished. (Courtesy of Maryland Historical Trust.)

Two

PATRIOTIC TIMES

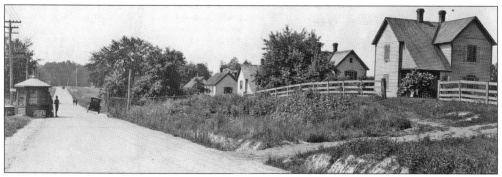

In October 1917, the federal government took over all the property on the Gunpowder Neck south of the railroad tracks to create the Edgewood Arsenal. This forever changed life in and around Edgewood. Thousands came to construct these facilities, and World War II brought a new influx of people. This photograph from the early 1920s shows the original World War I front gate. (Courtesy of US Army.)

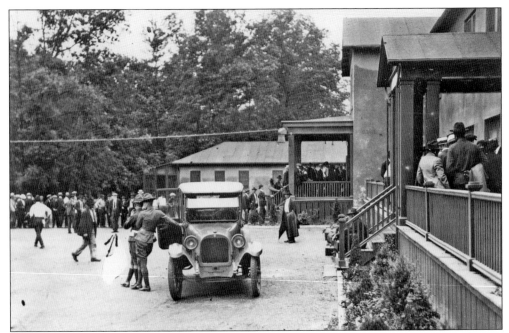

During the height of World War I, over 7,400 military personnel and 8,500 civilians were working at Edgewood Arsenal. There were long waits on paydays as civilian employees and military personnel lined up in long queues. Imagine just how long it took for everyone to actually get their salaries! Certainly, patience was needed. (Courtesy of US Army.)

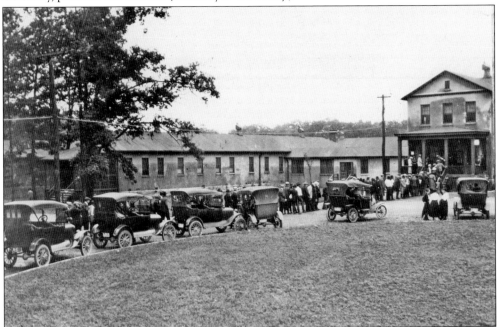

Paydays at the arsenal generated economic growth for the village of Edgewood. Businesses were created to fill the demand of those with money in their pockets. Wives were sometimes on hand to ensure that the pay actually made it home. Even some Model T automobiles were brought to the scene. (Courtesy of US Army.)

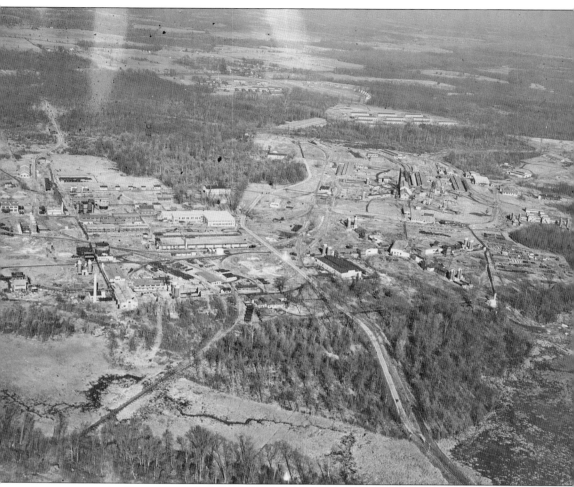

In response to the German introduction of chemical weapons, the US Army started a massive effort at Edgewood Arsenal to construct its own industrial complex to produce a variety of chemicals for weapons. Because there was no commercial application for most of these chemicals, the private sector did not produce them. This photograph provides an overview of the various facilities being built in the arsenal's early days. While the image does not show the entire complex, it does give some perspective on the size of the all-out effort of the US military to adapt to the age of chemical weaponry. Capt. Edwin Chance, a Philadelphia civil engineer, designed the first chemical shell filling plant, based on American bottling practices. The plant was operational in less than six months. Chloropicrin, mustard gas, and phosgene were produced at the arsenal. While the United States did not use chemical weapons in World War I, it did use incendiary bombs. The arsenal plant was designed to produce 2,000 incendiary bombs per day. (Courtesy of US Army.)

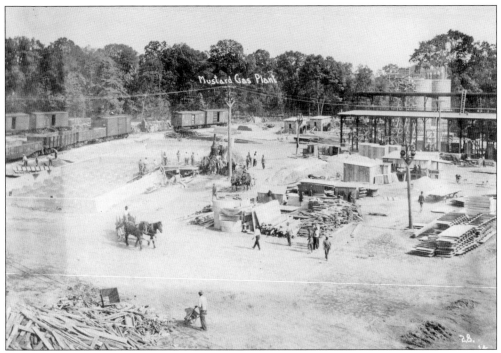

Mustard gas, known at one time as the "King of the Battlefield" because of its effectiveness, was first used by the Germans as a weapon in World War I. In response, the Mustard Gas Plant was started at the Edgewood Arsenal in May 1918. The building was completed in three months; this photograph was taken on June 27, in the midst of construction. (Courtesy of US Army.)

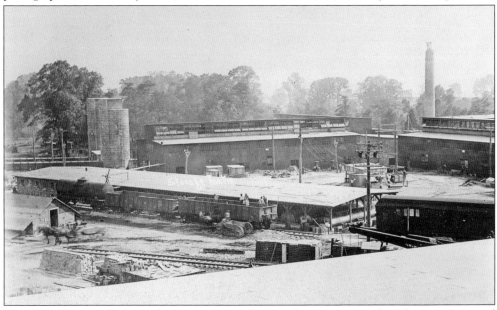

This 1918 photograph shows the construction of mustard gas storage tanks. The term "mustard gas" came from the smell of the German chemical agent. But the version of mustard gas produced at the arsenal was actually a liquid similar to motor oil and it smelled more like garlic. (Courtesy of US Army.)

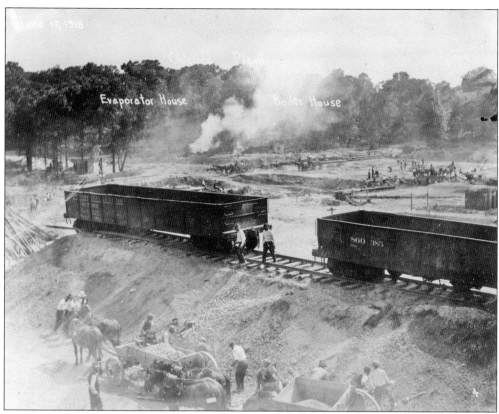

Using a full-steam-ahead approach, the arsenal personnel worked tirelessly using horses and wagons to lay the railroad tracks and get the various facilities, such as the evaporator house, chlorine plant, and boiler house, completed in a matter of months. The railroad spur, built in 1917, enabled needed supplies to be brought in by train from the Pennsylvania Railroad line. (Courtesy of US Army.)

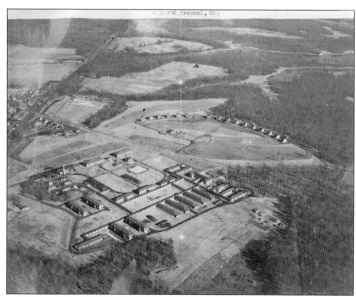

This 1929 aerial view of Edgewood Arsenal shows the village of Edgewood in the top left corner, next to the Pennsylvania Railroad line. The main entrance to the arsenal was just across the tracks. The houses in the semicircle were military officers' quarters. In the foreground is the arsenal's large hospital complex. (Courtesy of US Army.)

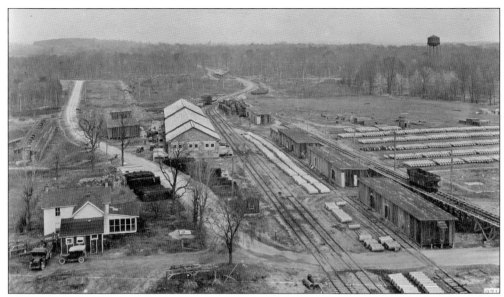

The farmhouse in the left foreground was likely inhabited by officers during the building of the nearby Mustard Production Plant but was subsequently used as a battalion headquarters. The dirt road brought many horse-drawn wagons of supplies to the production facilities. One-ton containers of chemical agents awaiting shipment to Allied forces in Europe were stored near the railroad spur. (Courtesy US Army.)

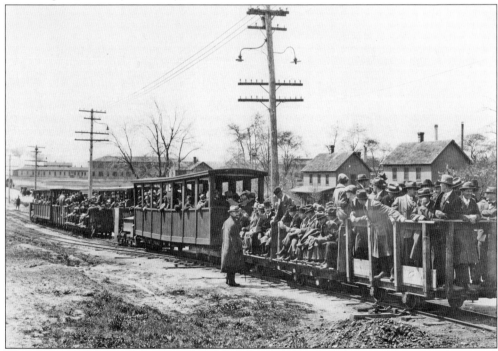

The Army developed a train system within the arsenal to move people, materiel, and weapons throughout the vast complex. This April 1924 photograph shows members of the American Chemical Society being transported to the different facilities on a passenger train, nicknamed the "Toonerville Trolley" after a newspaper cartoon. (Courtesy of US Army.)

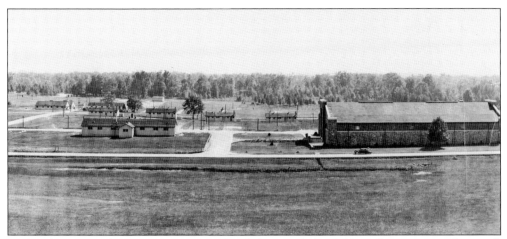

In October 1922, the War Department decided it needed a field artillery range and so took part of the Edgewood Arsenal to create Fort Hoyle. Since artillery units at the time were horse drawn, Fort Hoyle constructed an indoor riding facility to train horses. However, with World War II pending, Fort Hoyle was closed and the riding hall was converted into a gymnasium and recreation hall. (Courtesy of US Army.)

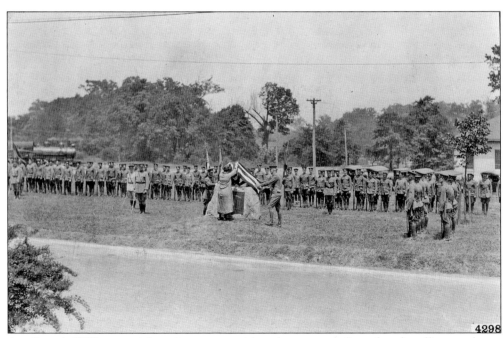

At a June 4, 1925, memorial service, a stone with a plaque was dedicated to the officers and men from Edgewood Arsenal's 1st Gas Regiment who died in service during World War I. (Courtesy of US Army.)

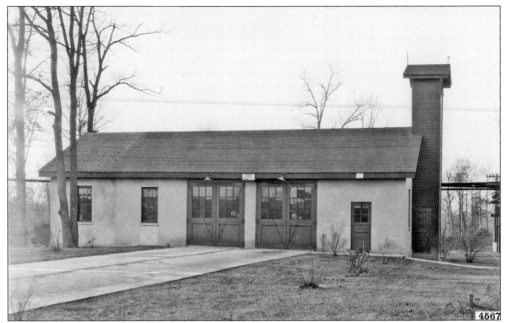

This is the Edgewood Arsenal's fire station as it appeared in 1927. Because of the arsenal's size and the fact that it was dealing with dangerous chemicals, having a fire department at the arsenal was essential. This was also the closest firehouse to the village of Edgewood. (Courtesy of US Army.)

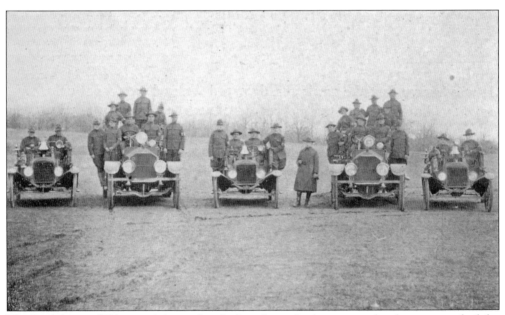

The firefighters of Edgewood Arsenal with their five vehicles were under the command of the fire marshal, Lieutenant Shaw (standing). With so many wooden structures at the arsenal, these firemen were kept busy. Even now, the firefighters from the arsenal are dispatched to help the two volunteer fire companies with structural fires in Edgewood. (Courtesy of US Army.)

In 1918, the US Army acquired property north of Route 40 along Edgewood Road where Winters Run flows. The dam and small building on the right were built in 1918 as the Van Bibber water treatment facility to provide a source of fresh water for Edgewood Arsenal. The building at bottom center was constructed in 1942 to accommodate the population growth at the Edgewood Arsenal. (Courtesy of US Army.)

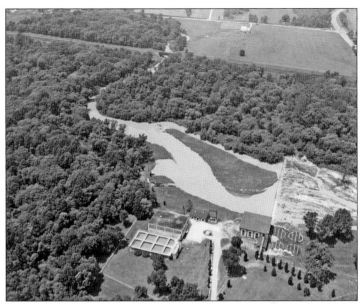

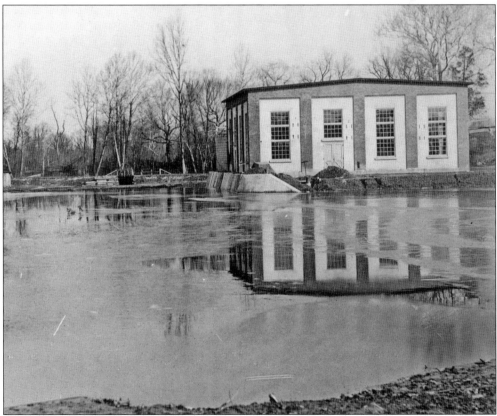

The 15-foot-high dam at the Van Bibber water treatment facility, built in 1918, backed up water from Winters Run so it could be drawn into the plant. The treated potable water then flowed via an underground aqueduct to the nearby Edgewood Arsenal. The dam was also designed to provide some reservoir storage capacity. (Courtesy of US Army.)

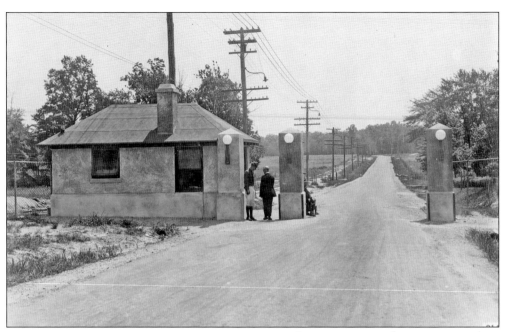

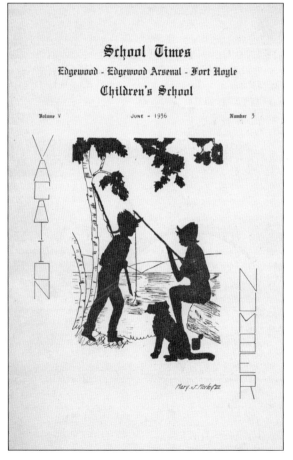

Improvements to the entrance road to the Edgewood Arsenal included a more modernized guardhouse, as shown in this 1920s photograph. Personnel were required to present appropriate identification to gain entrance to the arsenal. After Armistice Day, November 11, 1918, a rapid demobilization occurred. By August 1919, the total number of civilian and military personnel at the arsenal had been reduced to 915. (Courtesy of US Army.)

A school was established at the arsenal around 1920 for the children of military and civilian personnel. Under a 1923 agreement between Harford County and the military, other children from Edgewood also began attending this three-room school for grades one through seven. The school began publishing a pamphlet entitled *School Times*, such as this one from 1936, that included the children's essays and drawings. (Courtesy of Edgewood High School Alumni Association.)

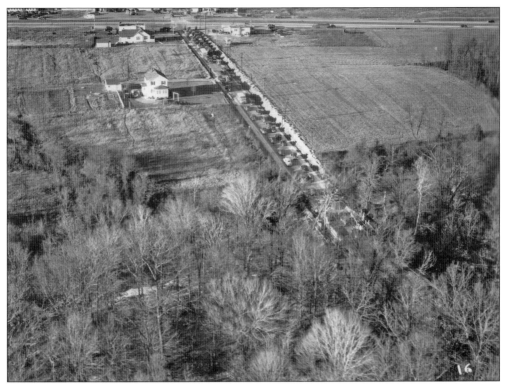

The main road leading into and out of Edgewood Arsenal in 1941 was Edgewood Road. About 10,000 civilians and 5,000 military persons worked on the arsenal during World War II, and automobile traffic was at its peak during commuting hours. Both lanes were used to facilitate movement of the commuters into the arsenal in the morning, and after work, the traffic pattern was reversed. (Courtesy of US Army.)

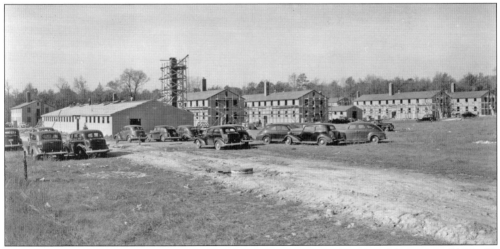

With the high demand for housing for non-military personnel at the arsenal during World War II, construction began in 1942 on the civilian dormitories, which were equipped to house and feed 569 people (378 men and 191 women). They had nine dormitories, three recreation halls, and a cafeteria and "Dormitory Exchange." They were operated under the jurisdiction of the Chemical Warfare Service. (Courtesy of US Army.)

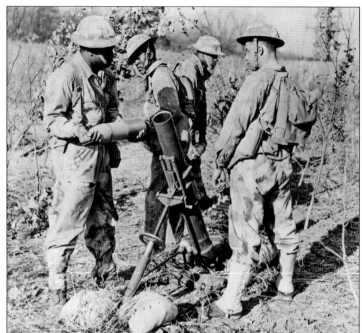

African American soldiers are shown at the arsenal training on the firing of the 4.2-inch mortar, which became the heart of the US Army's chemical warfare offensive capability in World War II. This mortar was capable of firing chemical agents if required but also high explosives, obscuring smokes, and white phosphorus rounds. The mortar could propel a round to distances exceeding 4,400 yards. (Courtesy of US Army.)

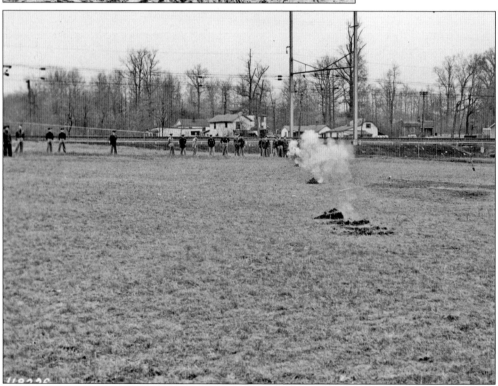

During a World War II training exercise conducted at Edgewood Arsenal, small quantities of diluted chemical warfare agents were explosively disseminated in the field. Soldiers learned to recognize the smell of various compounds and to take immediate action by donning a protective mask. These training exercises took place where the Exton golf course is now. (Courtesy of US Army.)

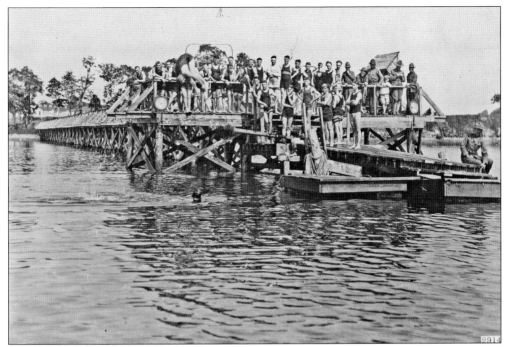

The arsenal's wooden recreation pier, sometimes referred to as the bathing pier, was located on the Gunpowder River. A dip in the cool water provided pleasant relief from the summer heat. The pier was conveniently in close proximity to the troop barracks. (Courtesy of US Army.)

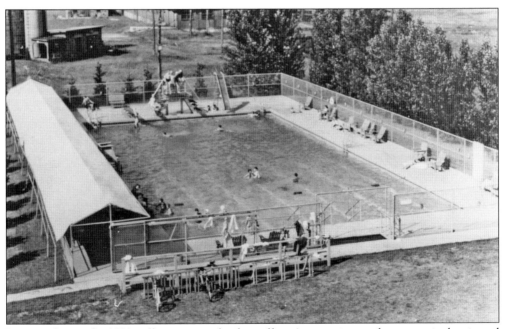

It seems that in the 1930s, all requests to fund an officers' swimming pool were routinely rejected by higher authorities, as a pool was considered a luxury. Post officials then asked for an "emergency emulsion pool" for a chemical weapons filling plant. This request was approved and the arsenal's first swimming pool was built in the middle of the shell-filling plants. (Courtesy of US Army.)

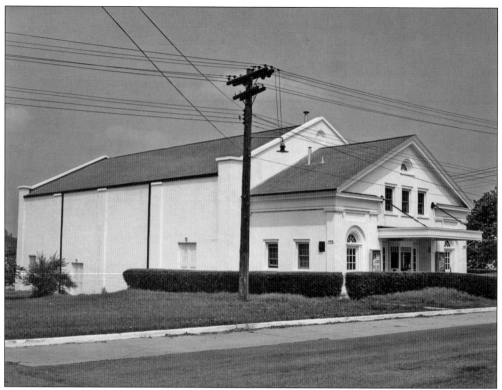

The post theater was built in 1934. In fell into disuse for a short time in the 1970s, but a group of enlisted soldiers volunteered their off-duty time to get the theater reopened. They took on the various tasks of running a movie theater, and in October 1977, the theater was reopened. The facility was converted into a conference center in 1985. (Courtesy of US Army.)

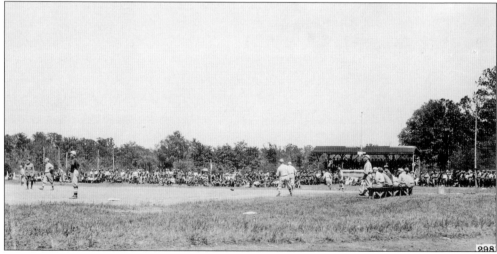

Organized sports were an important diversion for the men assigned to the arsenal, which was considered an isolated post. This 1919 baseball game was held at Walker Field. The athletic field, named for the first commander of Edgewood Arsenal, opened on July 1, 1918, and included a grandstand that could seat 1,500 persons. The arsenal's first baseball team won the Army-Navy Baseball League championship in 1918. (Courtesy of US Army.)

Three

HOUSING

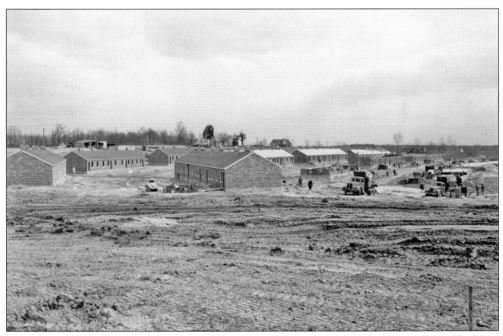

Housing in Edgewood changed radically in the 1940s, when the federal government started building hundreds of off-post housing units at various Edgewood locations to accommodate the large influx of people during World War II. The off-post housing complex seen here was constructed in 1943. Later, numerous housing developments were built. This chapter shows the changes in housing from the 1940s through the 1970s. (Courtesy of US Army.)

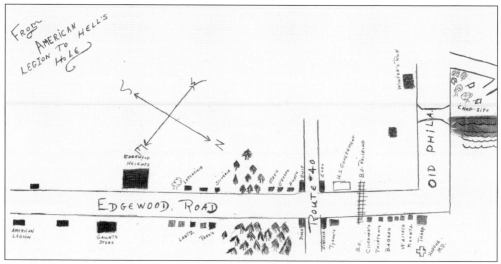

As a Boy Scout assignment, a young Bobby Coomes drew a map showing how to get from Edgewood's second American Legion Hall to a campsite called Hell's Hole. Apparently, the campsite got its name from its extremely deep pond. He included the landmarks and homes along the way. By holding on to his finished product all these years, Coomes preserved historical information about Edgewood. (Courtesy of Bobby Coomes.)

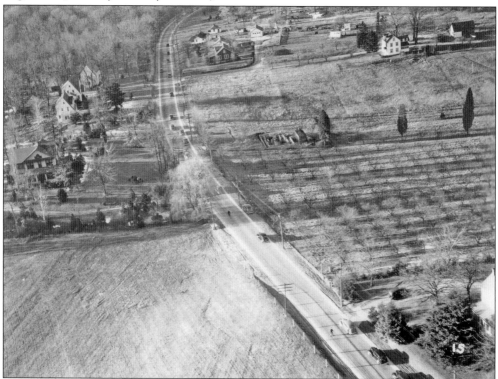

On Edgewood Road heading north toward Route 40, the large home on the left originally belonged to the Letchfield family. The home was built in 1910 and is located immediately north of the present-day Presbury Methodist Church. The next three houses along the road were built for family members of the Letchfield clan. They were constructed in 1935. (Courtesy of US Army.)

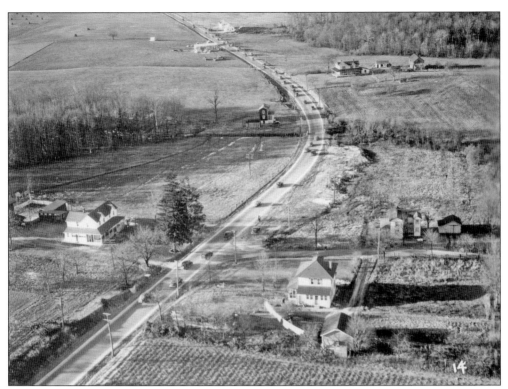

Once outside the small village near the train station, homes were much more dispersed. Leaving the village on Edgewood Road, traveling toward Route 40, the Marzicola family home, built in 1920, is visible at lower right with laundry hanging out to dry. (Courtesy of US Army.)

In 1941, the federal Public Buildings Administration began a project to create off-post housing to handle the rapidly increasing military and civilian workforce at Edgewood Arsenal and their families. The construction of the first housing unit can be seen in the center left of the photograph, taken looking north along Edgewood Road. (Courtesy of US Army.)

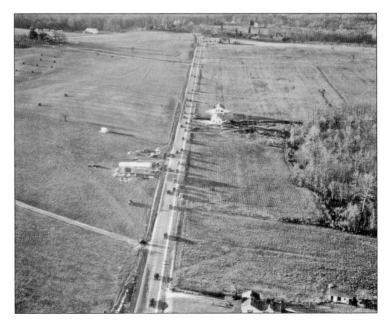

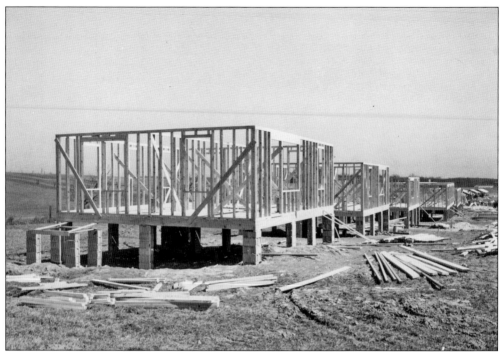

It did not take long for the housing units to start to multiply. With crawl spaces and not basements, and the same base floor plan repeated, the units went up quickly. Started in January 1941 and referred to as the Old Project, these dwellings for civilian employees of the arsenal were completed in July 1941. (Courtesy of US Army.)

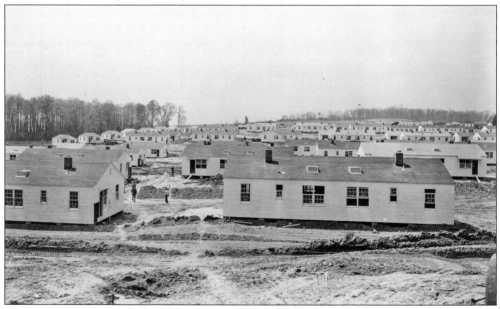

Since it was increasingly difficult to recruit labor from Baltimore and its surroundings, new neighborhoods were created in the immediate vicinity of the arsenal. The Old Project included housing facilities for 200 families and a community house for their use. Only civilian employees of the arsenal were eligible to live in this project. (Courtesy of US Army.)

50

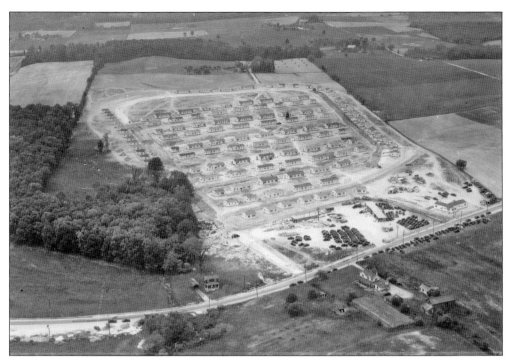

In 1941, the Public Buildings Administration built more than 125 housing units in an area known as Edgewood Heights. The heavily wooded area to the upper left of the housing complex was later cleared to make way for more housing. The new housing was constructed around 1944 and included the "colored project" on the north side and the "white project" on the south side. (Courtesy of US Army.)

Another view of Edgewood Heights from its western edge shows the village of Edgewood and Edgewood Road in the upper right corner. The photograph, taken in 1941, includes the Hanson family farmhouse in the foreground. Edgewood Heights was eventually razed to make way for the expansion of the Edgewood Elementary School complex. (Courtesy of US Army.)

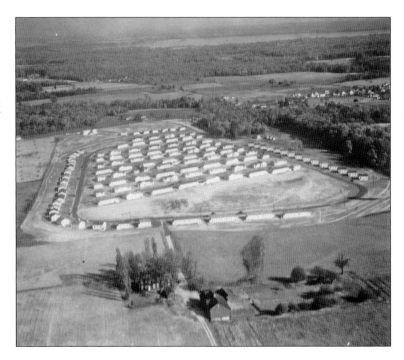

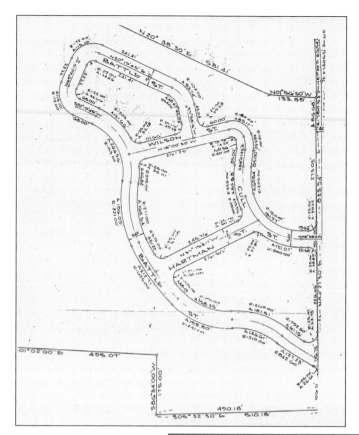

This is a Harford County street map showing the location of the "Colored Projects" during the segregated military housing days of the 1950s. These houses no longer exist, nor do the roads. Former residents of this area had asked county officials to provide a copy of the map for use at a Battle Street Reunion. (Courtesy of Geneva Pope.)

In this c. 1954 photograph, Wanda and Tessa Pope can be seen playing in the snow outside their Battle Street home. The segregated part of the military housing complex had its own community center, which served as a daytime nursery for small children. The community center also served as a home away from home for many black soldiers, and lively dances were often held there. (Courtesy of Geneva Pope.)

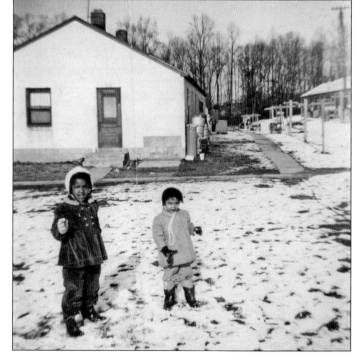

52

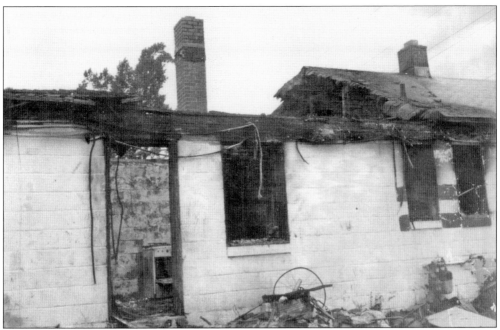

In June 1975, no one was reported injured in a fast-burning house fire on Battle Street, in the "colored" housing area. However, the family had no chance to save any clothing or household items. The occupant of the adjacent unit was able to salvage only a few pieces of clothing, while occupants of other units suffered smoke damage. (Photograph by June Hanson; courtesy of HCPL.)

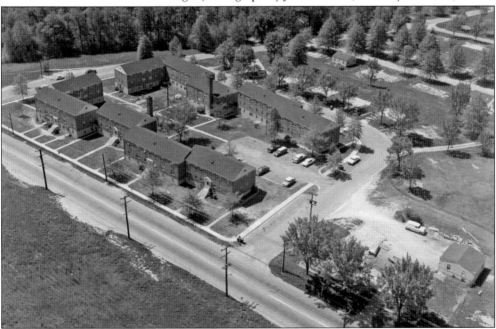

The necessity for even more military housing in the early 1950s led to development of several off-post housing complexes. One of them, Jackson Court, sometimes referred to as Harford Manor, was built on the left side of Edgewood Road heading north from the Edgewood Arsenal. It was constructed in 1950 and included 50 apartments in 10 units. (Courtesy of US Army.)

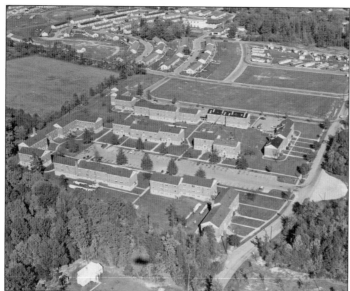

Lee Court, another off-post housing area, was constructed in 1950. It consisted of 28 units with 148 apartments for military personnel. Years later, when the military component at the arsenal was downsized, the Jackson Court and Lee Court apartment buildings were rented to civilians. Also in 1950, Grant Court was constructed on the post. It had 10 units with 56 apartments. (Courtesy of US Army.)

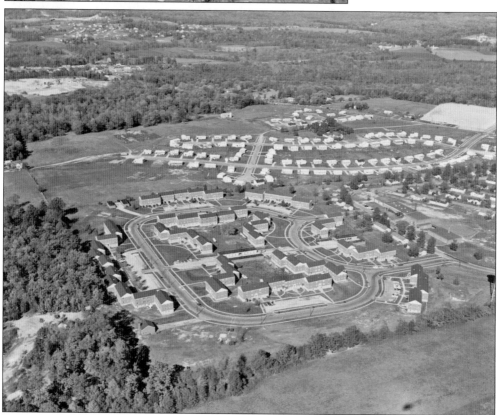

In 1952, the US government built a 55-unit brick apartment complex called Washington Court, located on 26 acres off of Cedar Drive. The complex provided 300 apartments to house military personnel and federal workers employed by Edgewood Arsenal. The apartments were vacated in 1994 and demolished in 2010. The single-family dwellings seen at the top were an early part of Edgewood Meadows. (Courtesy of US Army.)

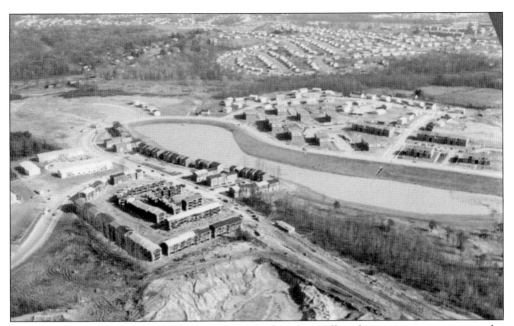

In this 1973 aerial photograph, construction of Edgewater Village housing units is seen in the foreground, with Lake Serene in the center and the Village of Lakeview on the other side of the lake. These developments are located on the former Edgewood TT Scramble motorcycle racetrack grounds. Edgewood Meadows is seen in the distance at the top. (Photograph by June Hanson; courtesy of HCPL.)

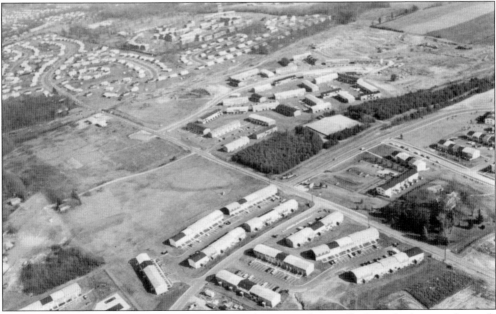

This April 1973 photograph shows Hanson Road running diagonally from the lower right, with Courts of Harford Square in the foreground and Edgewood Meadows in the background. The wooded area in the center, known as "The Pines," is owned by the US government. Subsequently, the Joppa-Magnolia Volunteer Fire Company leased it for $1 a year and built its No. 3 "Fort Hanson" station there. (Photograph by June Hanson; courtesy of HCPL.)

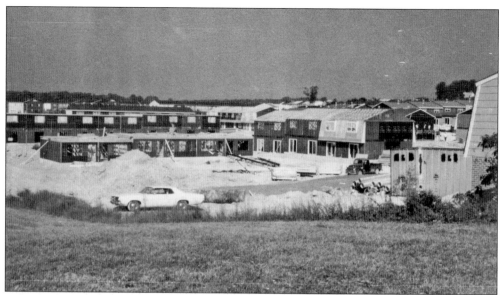

These Meadowood low-income rental units were erected in 1973 next to one of the two remaining dairy farms at the time. In the 1950s, there were 12 active dairy farms in this area south of Route 40. Beginning in 1997, the Community Preservation and Development Corporation acquired all 574 of these townhouses and renamed the complex Windsor Valley. (Photograph by June Hanson; courtesy of HCPL.)

More than 36 duplex houses had been sold at Willoughby Woods almost a month before the models were even opened for public inspection in 1973. They are located on Willoughby Beach Road, not far from the Bush River. A total of 416 homes were planned. (Photograph by June Hanson; courtesy of HCPL.)

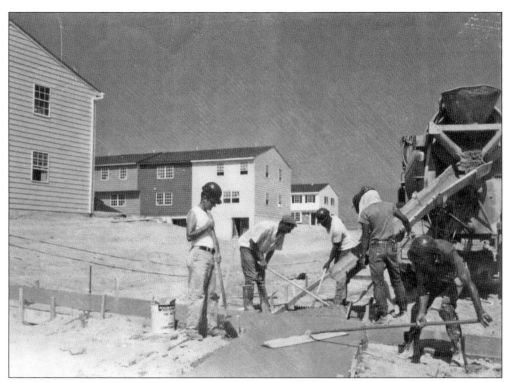

In 1973, these men were laying the sidewalks for the third section of the Harford Square development off of Hanson Road. This section alone accounted for more than 200 housing units. (Photograph by June Hanson; courtesy of HCPL.)

The Harford Mobile Village was established in 1973 with almost 400 spaces. It is located along Route 40 near the Ames Shopping Center. Behind the sign is a Hardee's restaurant that was being built concurrently with the mobile home village. Before that, this area was mostly wooded. (Photograph by June Hanson; courtesy of HCPL.)

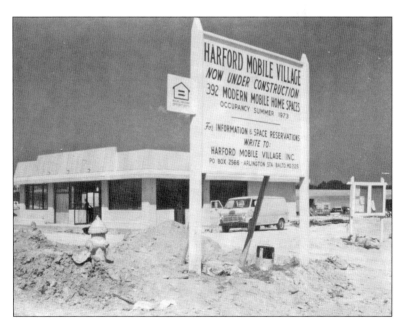

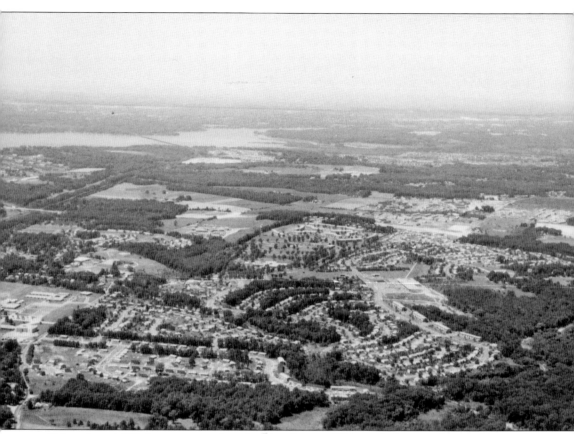

Taken from 4,000 feet on a very clear day, this August 1974 aerial photograph includes most but not all of Edgewood. The photographer explained that even at that height, she was unable to get such places as Crestwood Acres, Willoughby Woods, and Edgewater Village in the shot. Looking southwest, the high school complex is in the lower left. The new bridge over the Penn Central line is at center left. Edgewood Shopping Plaza is at right center. The Gunpowder River railroad bridge is at upper left, over the body of water. With these as guideposts, one can view the various neighborhoods. (Photograph by June Hanson; courtesy of HCPL.)

Four

COMMUNITY DEVELOPMENT

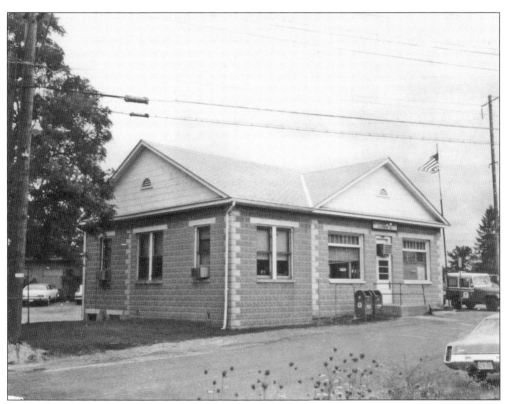

Edgewood derives its sense of community from the various rallying points such as its schools, churches, and volunteer organizations. This chapter shows the development of a number of these entities. The post office on Old Edgewood Road, seen here, was completed in 1939. The original Edgewood post office, created in 1866, was colocated with the train station. (Photograph by June Hanson; courtesy of HCPL.)

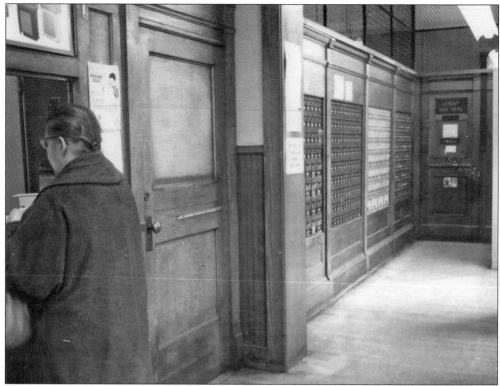

The post office on Old Edgewood Road, near the train station, was completed in 1939, but the government did not own the property. In 1933, John and Mary Frasch bought the property from the Philadelphia, Baltimore & Washington Railroad for $300 for the express use as a post office. John Frasch was the postmaster from 1937 to 1953. The post office built on this site was a small, utilitarian building. As the population of Edgewood continued to grow, so did the volume of mail that was generated. The below photograph shows the interior of the Edgewood Post Office in 1974. At that time, there were 18 postal workers to sort and deliver the mail. (Photographs by June Hanson; courtesy of HCPL.)

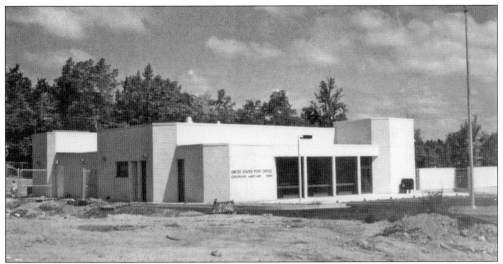

The Edgewood Post Office on Hanson Road, adjacent to the Edgewood Plaza Shopping Center, opened its doors for business on Monday, September 22, 1975. The single-story, brick-faced building is approximately 7,000 square feet. This site made the post office more convenient, because Edgewood's business and residential center had shifted away from its former site near the railroad. (Photograph by June Hanson; courtesy of HCPL.)

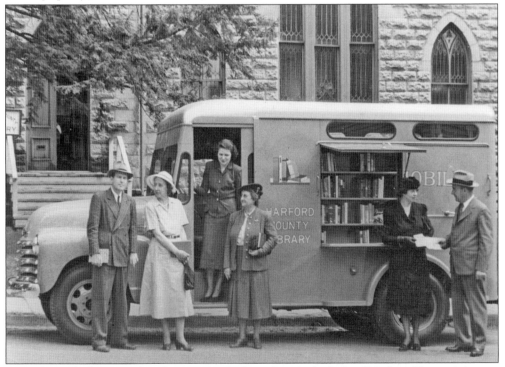

In 1945, Harford County bought a used vehicle and, with the help of Herbert Hanna (who ran a motor sales company), created a bookmobile to bring library services to Edgewood and other outlying communities. The Edgewood community was served by the bookmobile through weekly stops at the corner of Hanson and Tupelo Roads. Shown here in Bel Air, the bookmobile was very popular. (Courtesy of HCPL.)

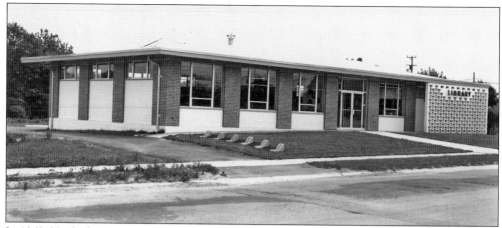

In 1962, Harford County authorized a permanent local branch library in Edgewood. The library was built on property donated by R. Walter Ward and Melvin Bosley of the Ward and Bosley Real Estate Firm. On December 15, 1963, the library officially opened, providing a 3,200-square-foot facility. (Courtesy of HCPL.)

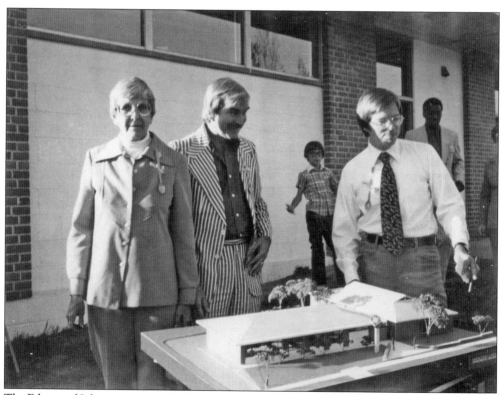

The Edgewood Library was expanded in 1979 with a 4,020-square-foot addition. In this photograph, from left to right, head librarian Roenna Fahnay, architect Edward L. Gray, and librarian David Clark show off the model of the Edgewood Library with that addition. In 2001, about 7,000 more square feet were added, making the current library more than five times its original size. (Courtesy of HCPL.)

Constructed around 1942, the Edgewood Elementary School on Cedar Drive was initially a single-story building (the portion of the school building at center, with the white mechanical equipment dotting the roof). When this photograph was taken, three additions had been constructed to provide extra classrooms and a cafeteria. After this photograph was taken, the gymnasium and library were added at the far left. (Courtesy of US Army.)

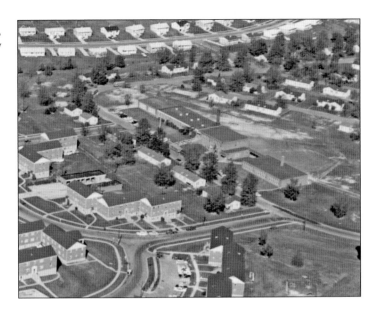

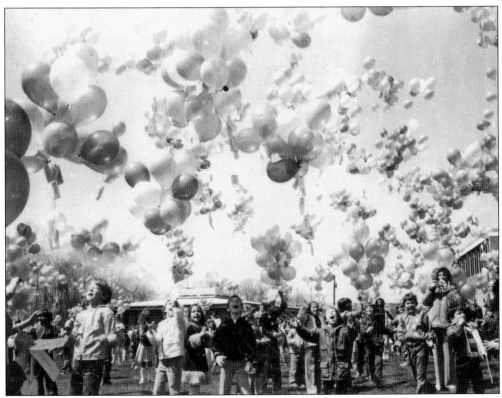

Deerfield Elementary School children launched 7,258 balloons during an annual Parent Teacher Association fundraising event in 1979. It took two days for volunteers to inflate, tie, and tag all the balloons. PTAs of other schools in the area also used balloon launchings to raise funds. (Photograph by June Hanson; courtesy of HCPL.)

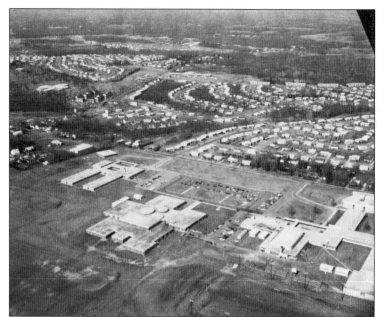

Looking northwest, this 1973 photograph shows three Edgewood schools located on a 102-acre site along Willoughby Beach Road. The old Edgewood High School on the right was substantially expanded in 1975 and then torn down in 2010. Edgewood Middle School is in the center, and Deerfield Elementary School is on the left. (Photograph by June Hanson; courtesy of HCPL.)

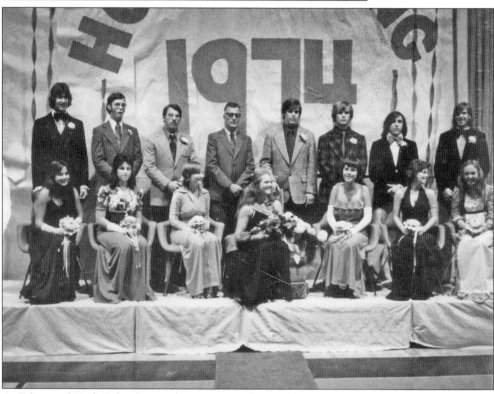

At Edgewood High School's 1974 homecoming dance, the new queen was crowned. Shown are, from left to right, (first row) Tammy Jennings, Pam Morrison, Nina Powers, Mary Porterfield (queen), Patty Procell, Alice Sexton, and Edna Stinefelt; (second row) Bill Baum, Larry Noel, Frank Smith, Bud Croakley (athletic director), Clay Mathews, Jack Orth, Henry Triplett, and Dave Kres. (Photograph by June Hanson; courtesy of HCPL.)

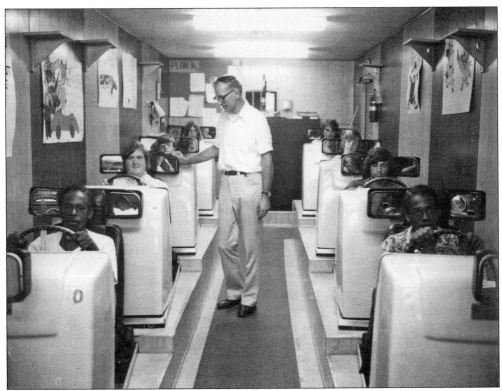

In 1973, the three-week driver education course offered at Edgewood High School included classroom sessions, behind-the-wheel training, and simulator experience. The simulator sessions were held in the Drivotrainer System Trailer parked outside the school buildings. Mr. Mawhinney and Mr. Pasqual taught the classroom sessions and the behind-the-wheel hours. More than 70 students signed up for the course. (Photograph by June Hanson; courtesy of HCPL.)

Edgewood High School varsity cheerleaders, from left to right, Pam Morrison, Barbara Billingsley, Rosaline Berry, the Edgewood Ramette (Alice Sexton), and Annette Pope washed cars at the Phillips 66 station on the corner of Edgewood and Hanson Roads in 1973 to raise funds for additional uniform items. The Ramette outfit was used in hopes of attracting more customers. (Photograph by June Hanson; courtesy of HCPL.)

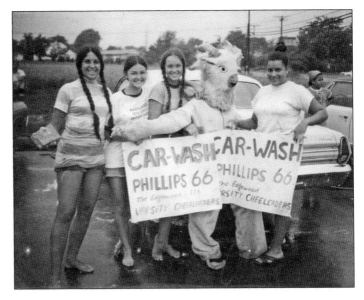

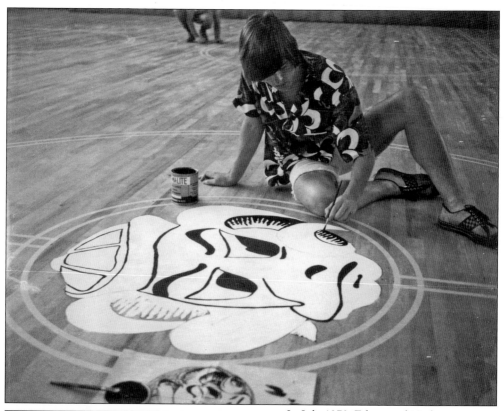

In July 1973, Edgewood High School senior Bill Watson returned to school early to paint the Ram mascot logo at center court of the school's gymnasium. It was a much different design than the one used later by the school. (Photograph by June Hanson; courtesy of HCPL.)

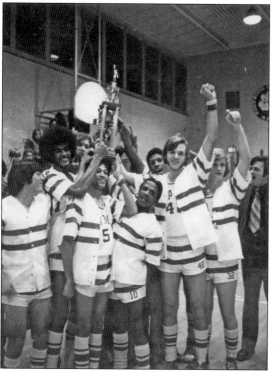

The Edgewood High School Rams were the 1973–1974 Harford County High School Class A basketball champions. This team had three players on the all-county first team (Dennis Compton, Dudley Bradley, and Jim Hutson), one on the second team (Steve Wilkinson), and one on the honorable mention list (Dwight Perry). The team made it to the semifinals for the state championship. (Photograph by June Hanson; courtesy of HCPL.)

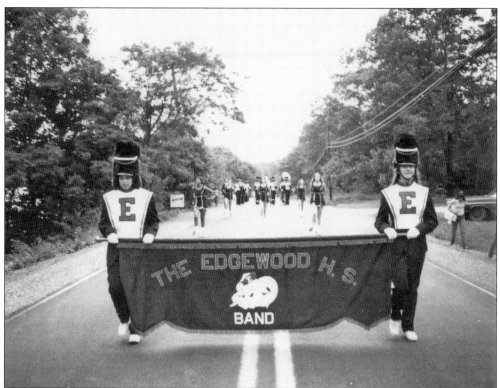

Denise Schloer (left) and Diane Gordon (right) carried the banner of the Edgewood High School band, followed by the baton twirlers and marching band in the 1976 Joppa Magnolia Firemen's Parade. (Photograph by June Hanson; courtesy of HCPL.)

The Edgewood Lions Club received its charter in 1947, and since then, it has been one of Edgewood's most influential service organizations. For example, recognizing the need for facilities to handle routine medical services, its members raised the money and erected two buildings to house doctors' offices and a clinic for the Harford County Department of Health. (Photograph by June Hanson, courtesy of HCPL.)

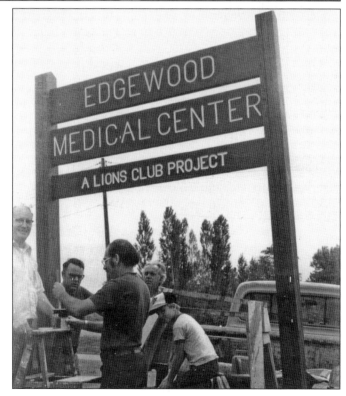

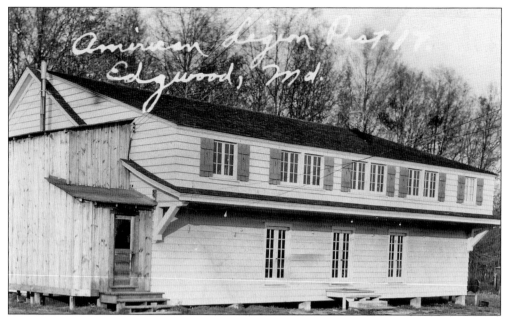

In 1931, Edgewood's American Legion Post 17 completed building it first post home. Initially a clubhouse, it was the first and only building in Maryland built for and by an American Legion post. It was named Martin Hall after M.Sgt. Aloysius Martin, who spearheaded efforts to start this post. This building is now the central, two-story portion of the Edgewood Auto Service facility. (Courtesy of David Rode.)

In 1946, American Legion Post 17 moved to the former USO building at 411 Edgewood Road, which was donated to the legion. Located on the property that the legion subsequently used as a parking lot, next to the current post home, the legion used this facility until December 1977. Initially constructed as a temporary structure, it had deteriorated badly by that time. (Courtesy of Prince of Peace Catholic Church.)

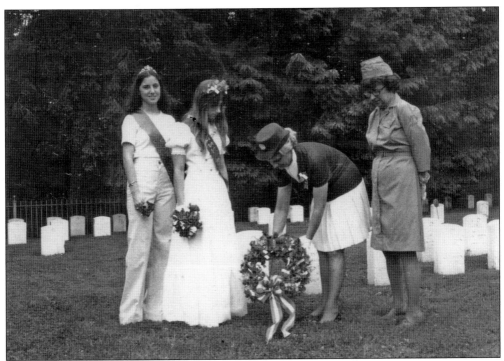

Edgewood has always demonstrated its respect and appreciation for the sacrifices made by the men and women in the military forces. The 1975 photograph above shows Elva Baer, president of the Edgewood American Legion Auxiliary, placing the wreath as part of the Memorial Day ceremony. Also shown, from left to right, are Veterans of Foreign Wars Buddy Poppy Queen Carol Caponic, American Legion Poppy Queen Muriel DeHaven, and Senior Vice President Leona Godfrey of the Veterans of Foreign Wars Post 5337. Together the women and girls placed poppies on each grave. In the below image, Mike Mahoney plays "Taps" to close the well-attended 1975 ceremony. (Photographs by June Hanson; courtesy of HCPL.)

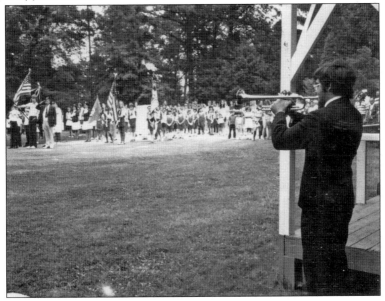

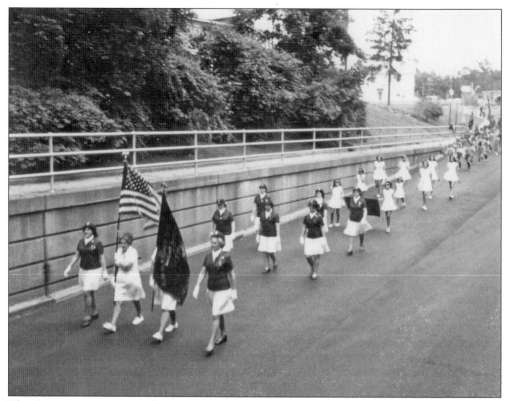

The American Legion Auxiliary Service Unit 17 and Junior Auxiliary look sharp marching into the underpass that goes to the Edgewood Arsenal as part of the 1975 Memorial Day parade. Over the years, the auxiliary, along with the Sons of the American Legion Squadron 17, has routinely assisted the legion in helping veterans and their families and sponsoring numerous activities for community children. (Photograph by June Hanson; courtesy of HCPL.)

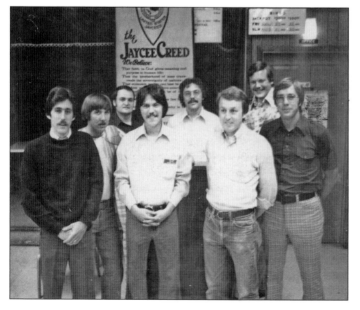

In May 1976, the Edgewood Junior Chamber (Jaycees) elected their new officers for the 1976–1977 term. The officers are, from left to right, Pres. Rick Noll, Secretary Richard Deise, Director Socky Price, Vice Pres. Harry Bell, Director Bob Getz, Treasurer Bill Noll, Chairman of the Board Richard Brezovec, and State Director Jim Hughes. Over the years, the Jaycees have done a great deal of community service in the area. (Photograph by June Hanson; courtesy of HCPL.)

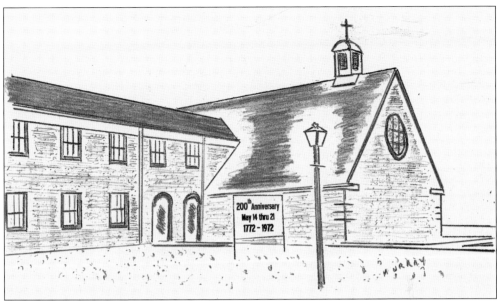

In 1968, the congregation of the Edgewood Methodist Episcopal Church merged with other Methodists to create the Presbury United Methodist Church on Edgewood Road. The church honors Joseph Presbury in its name because he was instrumental in establishing the Methodist church in Gunpowder Neck. In 1972, the congregation celebrated its 200-year heritage. (Courtesy of Joseph Murray.)

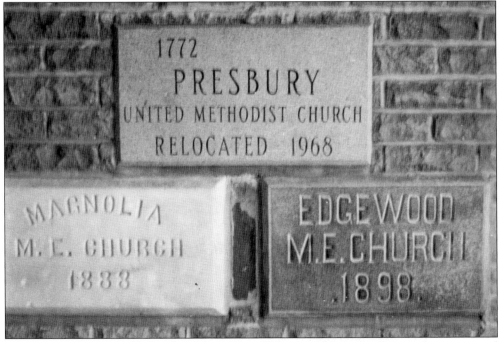

Cornerstones from two old churches, Magnolia and Edgewood Methodist Episcopal, are separated by a brick from the Presbury Preaching House to become part of the Presbury United Church on Edgewood Road. As the cornerstones attest, the current Presbury United Methodist Church can trace its roots back to 1772. (Photograph by June Hanson; courtesy of HCPL.)

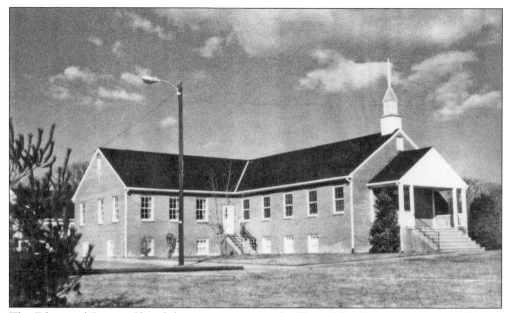

The Edgewood Baptist Church began as an outreach effort of the Oak Grove Baptist Church in Bel Air in 1953. It was originally known as Edgewood Heights Baptist Chapel. In 1955, the charter members of the congregation adopted the name Edgewood Baptist Church. (Photograph by June Hanson; courtesy of HCPL.)

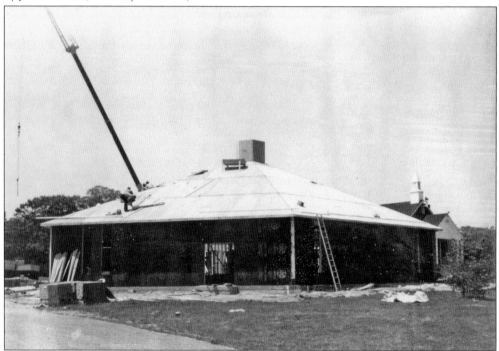

Because the congregation had continued to grow, the Edgewood Baptist Church built this hexagonal worship space in 1976 to expand existing facilities. The new sanctuary was not finished when this photograph was taken. The steeple had not even been put in place atop the center of the sanctuary. (Photograph by June Hanson; courtesy of HCPL.)

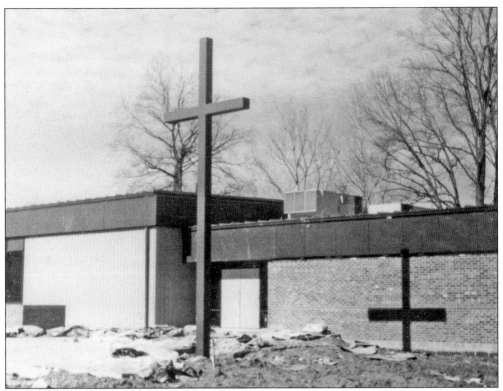

Prince of Peace Catholic Church started in 1977. After holding services in such places as the Edgewood Twin Theaters, American Legion Hall, and Presbury Methodist Church, the congregation built its parish center in 1982. The bronze statue of Jesus with arms extended that stands at the church's entrance was subsequently donated in memory of a teenager, Kevin Paznaniak, killed in an auto accident. (Courtesy of Prince of Peace Catholic Church.)

The 1982 dedication of the Prince of Peace Parish Center on Willoughby Beach Road was well attended by clergy and parishioners. Although not in this photograph, Archbishop William Borders of Baltimore presided over the dedication. After years of fundraising, the sanctuary was finally built in 1996. (Courtesy of Prince of Peace Catholic Church.)

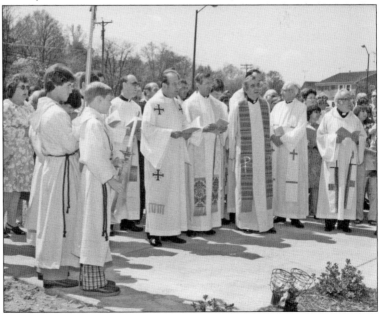

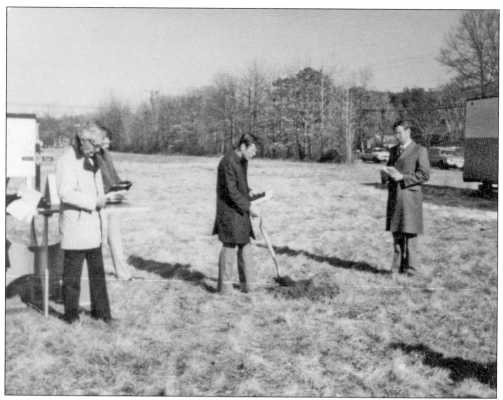

Lord of Life Lutheran Church was established in 1973, but getting to the point where the congregation was ready to build a permanent facility took a few years. At the 1980 ground-breaking for the church are, from left to right, John Carter, Darrell Brown (partially hidden), Rev. Henry Schaefer Jr., and building chairman Arthur Stuempfle. (Courtesy of Angela Wright.)

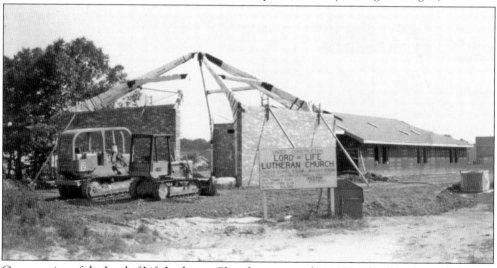

Construction of the Lord of Life Lutheran Church was started in 1980. The church was dedicated in 1981. Until the church was completed, the congregation had used the American Legion Hall and then the Edgewood Lions Club facilities for its services. The church is located on Willoughby Beach Road across from Edgewood High School. (Photograph by June Hanson; courtesy of HCPL.)

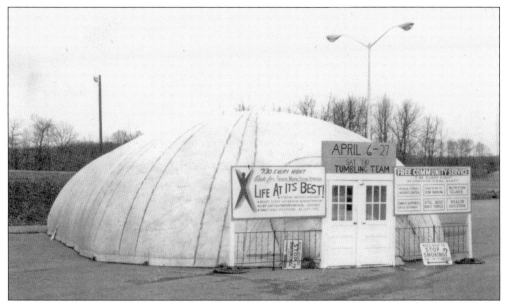

"Life At Its Best" community programs were held in this heated structure in April 1974 in the parking lot of the Ames Shopping Center. The Seventh-Day Adventist Church sponsored the program, which included fun features and specialists talking about various wellness issues. The structure's shell was a single layer of canvas held up by air pressure, and one needed to enter through two sets of doors. (Photograph by June Hanson; courtesy of HCPL.)

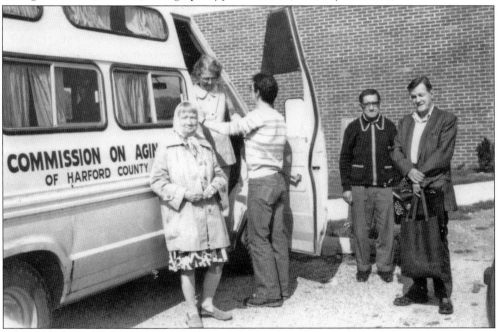

Eddie Hawkins, driver for the Harford Commission on Aging, is shown helping senior citizens from Edgewood, Abingdon, Belcamp, and Joppa disembark at the Edgewood American Legion Post 17 for an afternoon program of food, fun, and friendship. The program started in 1974 and provided lunch on weekdays. The Business Association of Southern Harford (BASH) provided gifts to be used as game prizes. (Photograph by June Hanson; courtesy of HCPL.)

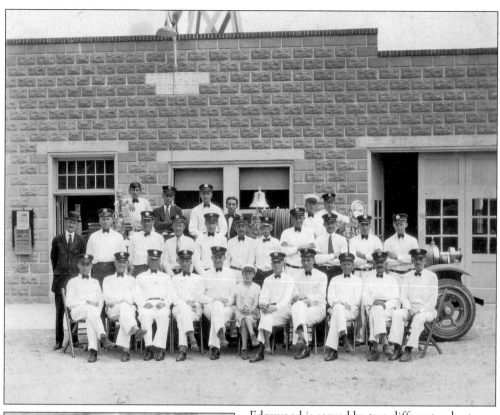

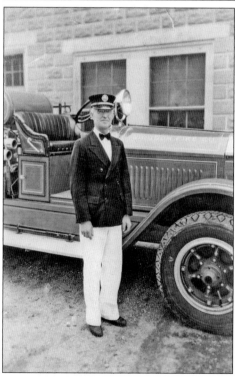

Edgewood is served by two different volunteer fire companies. The first firefighting class of the Abingdon Volunteer Fire Company is shown in the above photograph in front of its first vehicle, a 1926 Dodge truck with three 40-gallon chemical tanks. Chemicals were mixed with water in those tanks to create water pressure in the hoses. Firefighters had extra chemicals but had to rely on the homeowner's well for any additional water. With this one piece of equipment, the company served a territory of approximately 160 square miles, from the Baltimore County line on Route 40 on the west to several miles beyond Abingdon to the east and from Edgewood to the south to Emmorton to the north. The 1933 photograph at left shows Lon Moulsdale, who served as the chief of the Abingdon Volunteer Fire Company. (Both, courtesy of Abingdon Fire Company.)

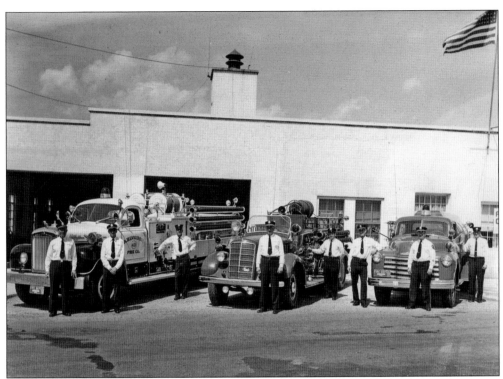

In this c. 1958 photograph, members of the Abingdon Volunteer Fire Company are seen showing off their 1957 Mack, 1940 Mack, and 1951 Chevrolet tanker truck. Abingdon Fire Company has served Edgewood residents since 1925, but it was not until June 1979 that it opened a fire house on Laburnum Road in the Willoughby Beach area of Edgewood. It was used for 27 years. The Abingdon Fire Company swapped that fire house with the Willoughby Woods Landowners Association for the land on Willoughby Beach Road to build a new station. It opened in October 2006, and the company is still interested in finding more volunteers. Below, Abingdon fire chief Chas S. Sewell poses with the then-new 1957 Mack pumper. (Both, courtesy of Abingdon Fire Company.)

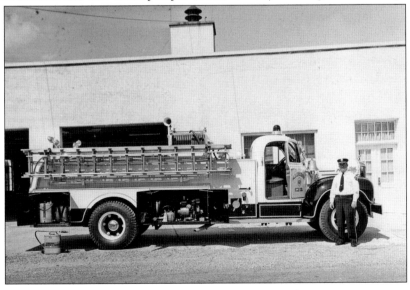

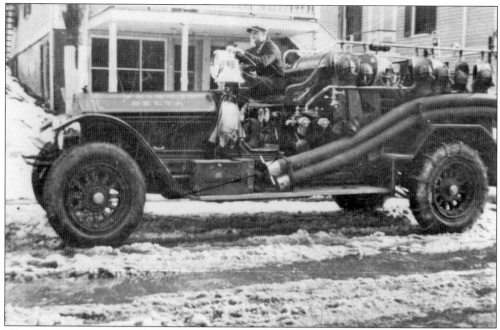

This 1924 American LaFrance pumper was the first piece of apparatus owned by the Joppa-Magnolia Volunteer Fire Company. It was purchased in 1952 for a token $1 from the Delta-Cardiff Volunteer Fire Company. It was used for fundraising and membership drives. (Courtesy of Joppa-Magnolia Volunteer Fire Company.)

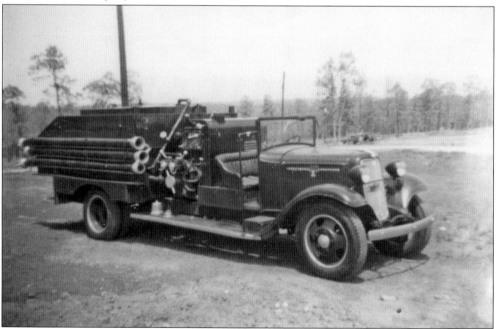

The Joppa-Magnolia Volunteer Fire Company purchased this 1934 Ford from Cowenton (now White Marsh). It replaced the 1924 American LaFrance. The pumper was a school bus prior to World War II, but Civil Defense converted it into a fire apparatus during the war. (Courtesy of Joppa-Magnolia Volunteer Fire Company.)

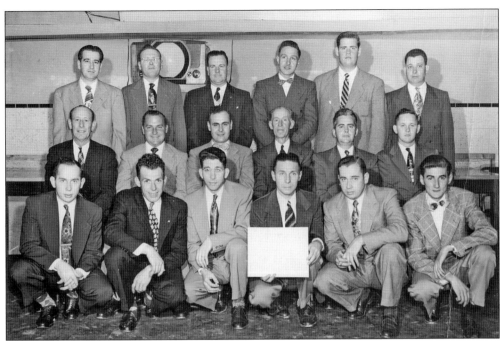

Members of the first of class of Joppa-Magnolia volunteer firefighters are, from left to right, as follows: (first row) Richard Henning, William Kimmel, Earl Pierce, Chief Milton Sniegowski, Kenneth Henning, and John Holter; (second row) Walter Anthony, Harold Spicer, Bernard Bapke, John Fitzgerald, Edger Williams, and Sam Jones; (third row) William Blevens, Walter Skillman, Claude Crouse, Aaron Anderson, Jerry Cook, and Charles Pierce. Donald Ryan is not pictured. (Courtesy of Joppa-Magnolia Volunteer Fire Company.)

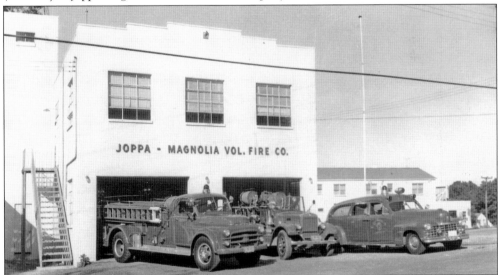

This c. 1956 photograph shows the Joppa-Magnolia Volunteer Fire Company with its 1953 Dodge pumper, 1934 Mack pumper, and 1948 Cadillac ambulance on display. Although the fire company has served Edgewood since the 1950s, it built a substation in Edgewood in 1992. Nicknamed Fort Hanson, the substation was built on federal property leased to the fire company for $1 per year. (Courtesy of Joppa-Magnolia Volunteer Fire Company.)

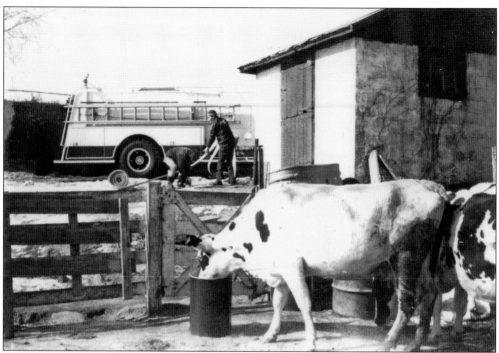

In February 1977, the Abingdon and Joppa-Magnolia Volunteer Fire Companies joined forces to come to the aid of thirsty dairy cows. The water pipes at the dairy farm of Edwin Hanson (June Hanson's husband) had frozen in the extreme cold. Since one cow can drink 20 or more gallons of water a day, and there were 40 cows, the volunteer fire companies came several times to provide the cows with water. (Photograph by June Hanson, courtesy of HCPL.)

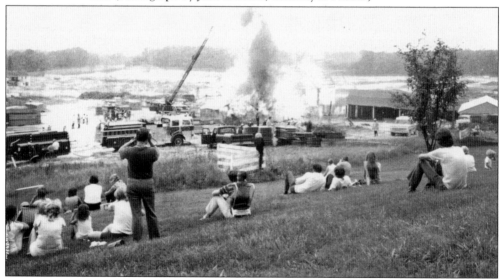

The dairy barn formerly owned by Thomas Earl Hanson was deliberately set afire in July 1972 to train six different fire companies (Abingdon, Joppa-Magnolia, Bel Air, Level, Aberdeen, and Kingsville). A number of spectators watched while firefighters trained on keeping the flames where they wanted them, saving sheds within 10 feet of the barn. (Photograph by June Hanson; courtesy of HCPL.)

Five

BUSINESS

This 1937 photograph shows some of the stores that used to exist in the village of Edgewood near the train station. Included in this image are Bosart Perry's grocery store, Shapiro's furniture store, and Kaplan's military supply store. The completion of Route 40 and Interstate 95 shifted the commercial and business activities of Edgewood away from the area near the station. (Courtesy of Margaret Oakley.)

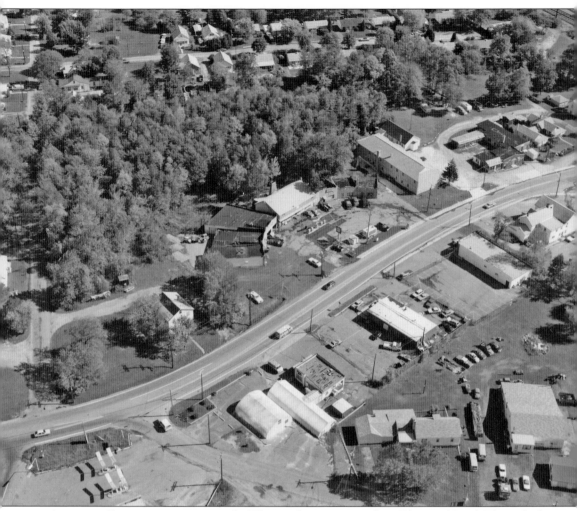

A variety of businesses grew up near the Edgewood train station along Edgewood Road. The arched complex in the center of the photograph housed Art Brinkman's service station and hardware store. This originally was the American Legion's meeting place and had a large stone fireplace inside. On the right side of the complex was a flower shop that later became a television repair shop. On the left side was the Edgewood Drug Center, known as "Doc's Shop." The long white building to the right of the complex was Forward Step, a women's crisis center. The two Quonset-type structures on the other side of Edgewood Road next to Nuttal Avenue housed Dr. Charles Williamson's Jungle Gems Orchids store and nursery. Other businesses in the area included a donut shop and Wilt's Carry Out Sub Shop, where a submarine sandwich could be purchased in the 1960s for 50¢. Houses along Oak Street can be seen at the top of the photograph. (Courtesy of David Rode.)

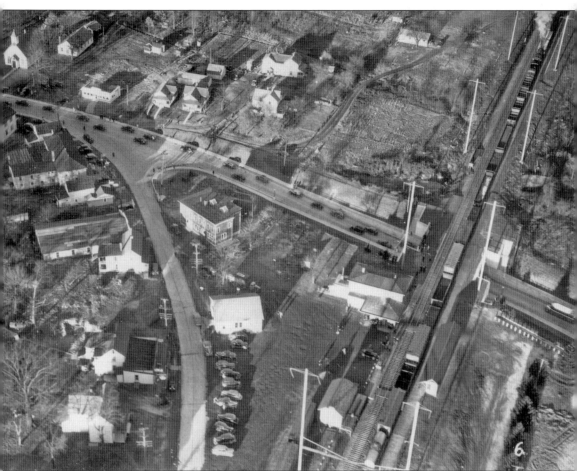

Vehicular traffic is seen leaving the Edgewood Arsenal at 4:00 p.m. in 1941 and heading north under the Pennsylvania Railroad overpass on Edgewood Road. The railroad overpass was constructed in 1939; previously, the entrance to the arsenal was reached by crossing over the railroad tracks along Old Edgewood Road (once known as Railroad Avenue), also shown intersecting with Edgewood Road. The steam engine leading the train is on the right, along with the Edgewood station on the north and south sides of the tracks. Along Old Edgewood Road, starting on the right side from Edgewood Road, is Loughlin's hotel and pub, built in 1916 and originally intended to serve railroad passengers. Next to Loughlin's is the Edgewood Post Office. The Edgewood Methodist Church, built in 1898, is in the upper left corner of the photograph. The house on the lower left corner belonged to Dr. Charles Roth, the first medical doctor in Edgewood, who began his practice in 1898 at the age of 25. (Courtesy of US Army.)

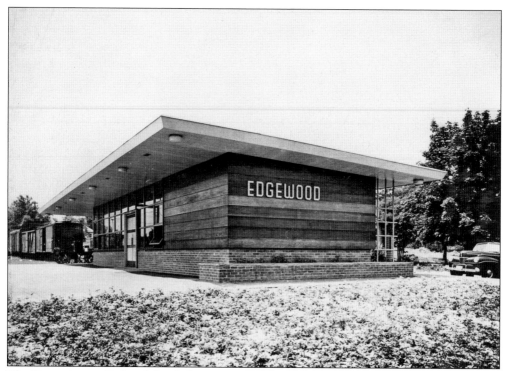

The Pennsylvania Railroad decided to erect a modern passenger train station in Edgewood in 1942 to handle the large volume of people going to the nearby military base. The station was a sleek, horizontally designed, one-story building made of redwood plank siding and brick, with an overhanging roof and a large bank of windows. The waiting room had modern, cantilevered wooden benches. (Courtesy of Hagley Library and Museum.)

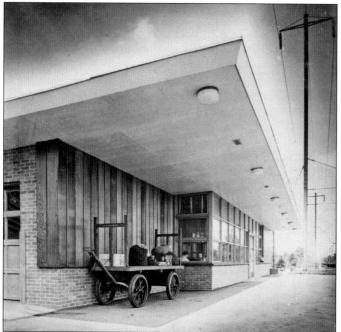

The new station drew the attention of prominent publications such as *Time* magazine and *Architectural Forum*. In March 1942, *Time* called the new station "light, airy and cheerful as a country-club terrace." It added that the "huge plate glass window gives waiting travelers a complete view of all incoming and outgoing trains." *Architectural Forum* remarked on the way the station's features added warmth and distinction. (Courtesy of Hagley Library and Museum.)

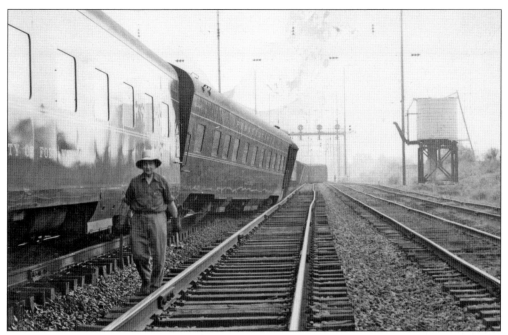

This photograph was taken to record the 1940s derailment of a Pennsylvania Railroad train in Edgewood. It also captured the old water tower, which had been used for decades to replenish the water for steam-driven engines. (Photograph by C.W. Bruss; courtesy of Al Bair.)

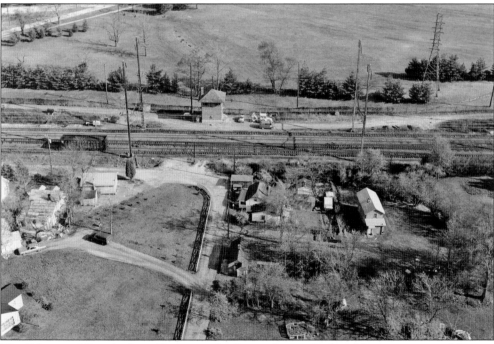

The Edgewood Interlocking Tower on the Pennsylvania Railroad line was manned by two persons at a time, 24 hours a day. The tower controlled the track switches at the Bush River, Edgewood, Magnolia, and Gunpowder Interlockings. It was closed on May 19, 1988. (Courtesy of US Army.)

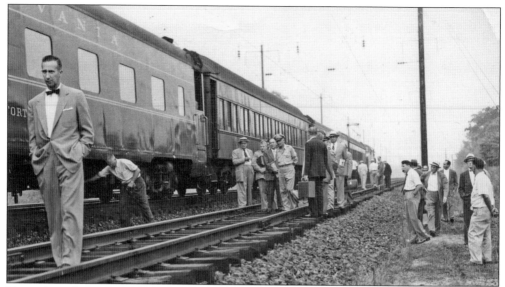

Trains have been coming through Edgewood since 1837. The railway owners changed from Baltimore & Port Deposit Railroad (in 1837) to Philadelphia, Wilmington & Baltimore Railroad (in 1838), Philadelphia, Baltimore & Washington Railroad (in 1902), Pennsylvania Railroad (in 1918), Penn Central Railroad (in 1961), and Conrail (in 1976). The train tracks through Edgewood are straight, and derailments like this one in the 1940s have been few. (Photograph by C.W. Bruss; courtesy of Al Bair.)

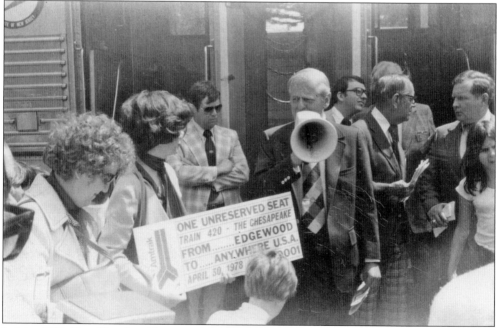

In May 1978, Gov. Blair Lee (shown with bullhorn) was in Edgewood to announce the opening of the Amtrak station. An Amtrak public relations specialist displayed a simulated ticket indicating the return of local rail service. The Edgewood train station has varied from the original two-story building to a sleek, horizontally designed, one-story building made of redwood and brick to a trailer where tickets are sold. (Photograph by June Hanson; courtesy of HCPL.)

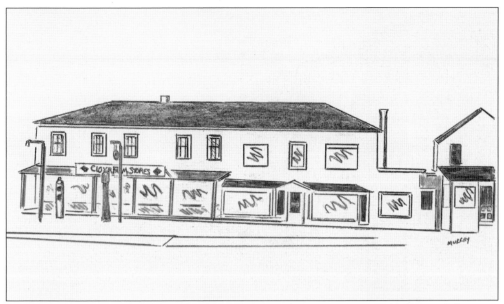

This sketch provides a glance of what once constituted a major portion of Edgewood's business district near the railroad station. At one time, "Boss" Hanson had used this building for canning tomatoes. It later housed grocery, furniture, and military supply stores. The grocery became known as Zeigler's Store and then Perry's Market. (Courtesy of Joseph Murray.)

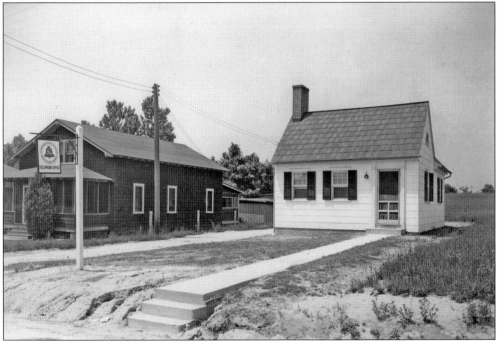

The telephone office building was located on Edgewood Road. The house on the left, at 404 Edgewood Road, was constructed in 1929. The first telephone installed in Edgewood was in Dr. Roth's home, located on Railroad Avenue. Telephones were first installed in the Edgewood Heights project homes in 1950; previous to that, access to a telephone was in a booth on Battle Street. (Courtesy of US Army.)

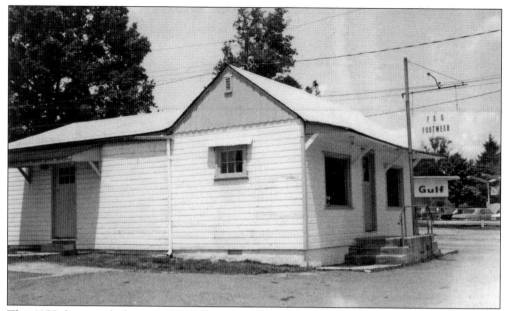

This 1975 photograph shows the F&G Shoes store, located on Nuttal Avenue near Edgewood Road in a structure that previously held Craig's Grocery. F and G were the first initials of the owners, Frank and Goldie Caudill. Frank Caudill also owned the Gulf service station at the corner of Trimble and Edgewood Roads. One year later, F&G moved to Edgewood Plaza Shopping Center. (Photograph by June Hanson; courtesy of HCPL.)

After the new post office opened on Hanson Road in 1975, the old building was leased by the Harlow and Bogart unisex hair care shop. While the exterior looked much the same as before, the interior was transformed, with antique furniture and many large houseplants in the shop's waiting room. Subsequently, the building lay vacant for a number of years and deteriorated. It was demolished in September 2008. (Photograph by June Hanson; courtesy of HCPL.)

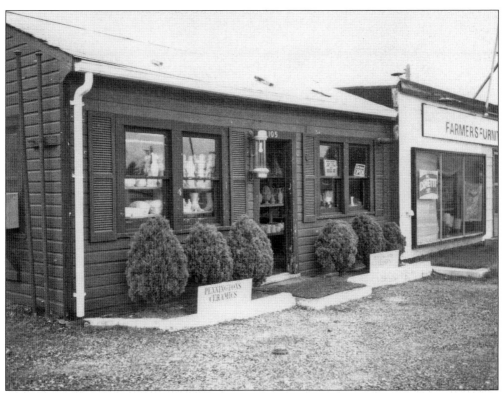

Pennington Ceramics opened for business in September 1975 next to the Farmers Furniture Discount Store. The building complex is on the east side of Edgewood Road near the train station. The ceramics shop was unsuccessful and soon was replaced by the Straw Hat Antiques store. Next to the furniture store was the Campus Diner, owned by Tony Mascota; later it was called Rose's Diner. (Photograph by June Hanson; courtesy of HCPL.)

The Edgewood Drug Center closed in 1972. It was next to Brinkman's service station and hardware store on Edgewood Road. This was the final sale of "Doc's Shop," as it was slangily called. "Doc" Schwartz retired from the business. (Photograph by June Hanson; courtesy of HCPL.)

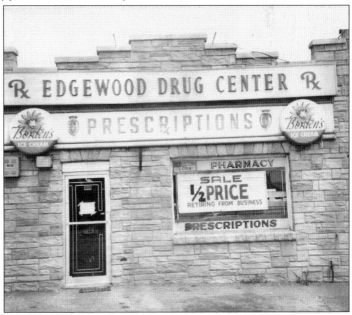

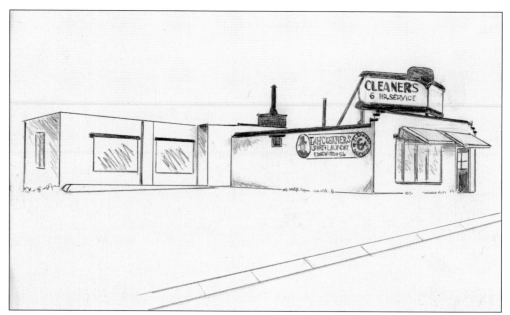

L&H Cleaners was located on the corner of Edgewood Road and Willoughby Beach Road. The store's proximity to the Edgewood Arsenal, along with the demand for clean, pressed, and starched uniforms for the military personnel and this company's promise of six-hour service, combined to make it a prosperous business in the 1940s and 1950s. (Courtesy of Joseph Murray.)

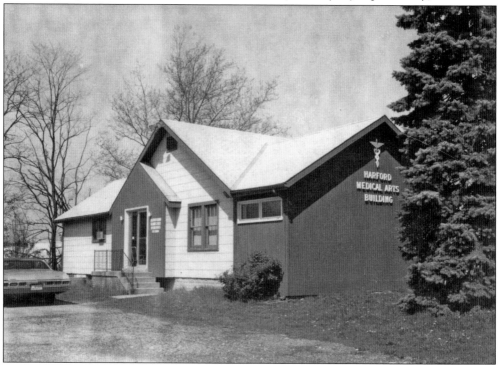

The Harford Medical Arts Building was located on Edgewood Road near Route 40. In the spring of 1973, Dr. Reynaldo Guzman opened a new pediatrics practice in Edgewood under the sponsorship of the Edgewood Lions Club. (Photograph by June Hanson; courtesy of HCPL.)

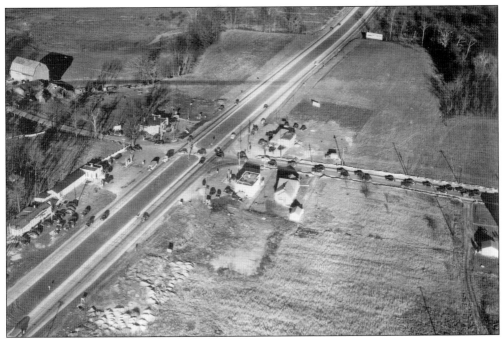

The intersection of Edgewood Road and Route 40 is shown in this 1941 aerial photograph. The Sinclair service station is at the top left of the intersection, the Edgewood Diner on the top right, the Gulf service station on the bottom right, and the Esso service station and Drago's Restaurant on the bottom left. The Tyson family's farmhouse and large barn are at the top left of the photograph. (Courtesy of US Army.)

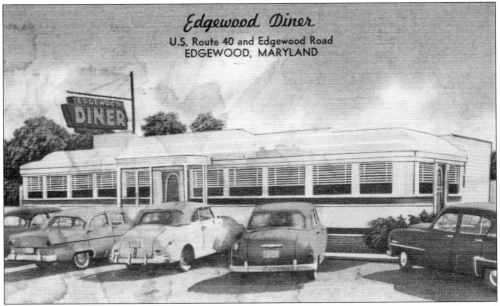

The Edgewood Diner was owned by James O'Keefe. It was located at the corner of Edgewood Road and Pulaski Highway (where the Edgewood McDonald's is now). Open 24 hours a day, the diner's motto was, "Eat where you can see your food prepared." It was sold at auction in March 1972. (Courtesy of Thomas Paul.)

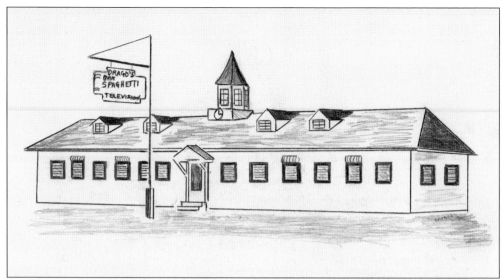

In the 1950s, Drago's Restaurant on Route 40 was the place to go for Italian dinners. Because Route 40 was the main travel route between Philadelphia and Baltimore, Drago's was a convenient stopping place for travelers. Spaghetti and meatballs was its specialty. (Courtesy of Joseph Murray.)

Curtis Coomes opened the White Star Restaurant in 1947. At the time, there were very few places to go out to eat in Edgewood. The Coomes family ran the restaurant for 35 years. The restaurant grew and flourished by changing with the times. The Coomes family catered many senior citizen dinners, routinely sent their famous salads to local bereaved families, and contributed to many civic projects. (Courtesy of Bobby Coomes.)

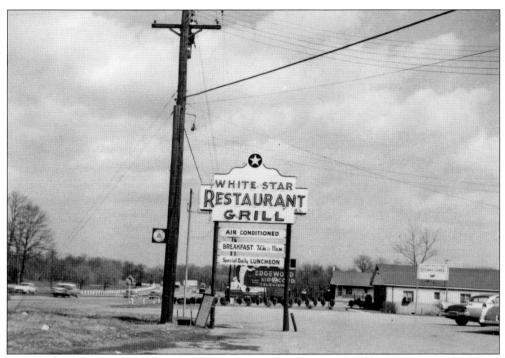

In 1959, the blinking star atop the sign in front of the White Star Restaurant could be seen for miles. The sign boasted air-conditioning, while the sign on the building advertised steamed crabs, a favorite meal for many people in Edgewood. The Motel Edgewood can be seen in the background. (Courtesy of Bobby Coomes.)

In April 1959, Curtis Coomes, shown here, and son Bobby Coomes installed a drive-in feature to the White Star Restaurant. According to Peggy Sexton, driving up to those speakers to place an order seemed to the teenagers just like being in Hollywood. In the 1960s, the White Star Restaurant sold "Star Boy" hamburgers, which were a big hit, as were the "Crispy Ques" French fries. (Courtesy of Bobby Coomes.)

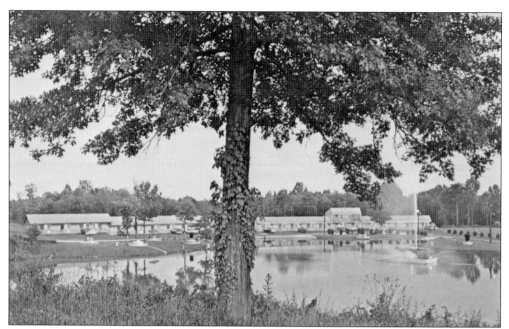

Lakeside Motel, located at the corner of Pulaski Highway (Route 40) and Magnolia Road, offered accommodations 600 feet away from the road. Originally, the accommodations were steam-heated cottages. Swimming, fishing, boating, and ice-skating on its private lake were free to guests. Its advertisement read, "Best stop going north or south. Make your reservations for summer or winter vacation." The motel and restaurant were run by Mr. and Mrs. Forney in the 1940s. The Lakeside Restaurant's gourmet menu featured a variety of expertly prepared entrees, including steak, seafood, and chicken. Locals considered it a classy restaurant. The basement had a bar and shuffleboard. Shuffleboard tournaments were often held there. (Both, courtesy of Thomas Paul.)

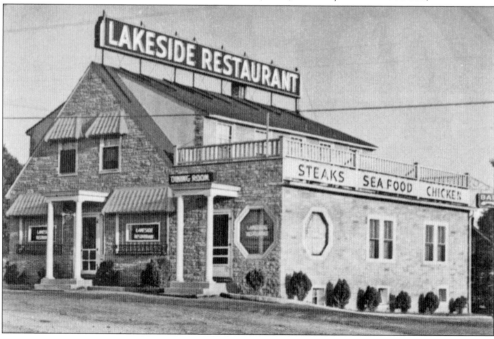

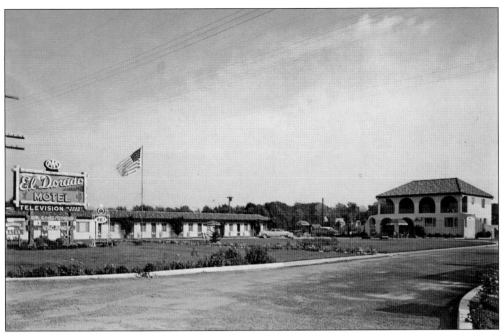

El Dorado Motel on Pulaski Highway was built in 1950. The red-tile roof provided flair to the Mexican ranch-type buildings. This 20-unit motel advertised that it was the "finest anywhere" and that the large cross-ventilated rooms were luxuriously appointed with modern furniture. It was reportedly constructed with fireproof material. (Courtesy of Thomas Paul.)

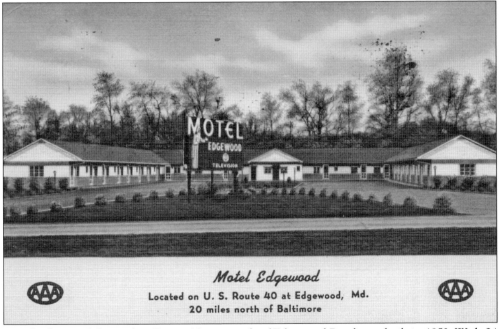

Motel Edgewood, located on Route 40 just north of Edgewood Road, was built in 1953. With 24 units, it advertised that one could get luxuriously furnished rooms with or without air-conditioning. Its location made it convenient for travelers to get to nearby eating places such as the White Star Restaurant, the Edgewood Diner, and Drago's. (Courtesy of Thomas Paul.)

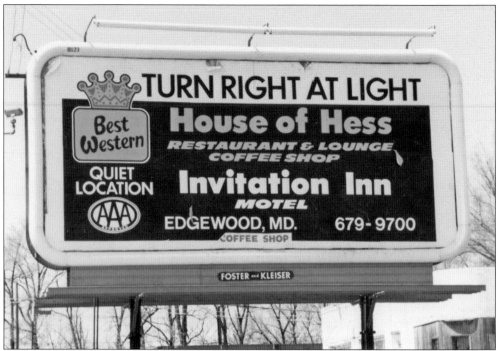

The Invitation Inn Motel, located at 1709 Edgewood Road at Maryland Route 24 (then off exit 4 and now exit 77-A on Interstate 95), was constructed in 1966. It became part of the Best Western chain in 1967 and first advertised itself as the only motel on Interstate 95 in Maryland. The 80 ultramodern rooms featured television, air-conditioning, room phones, combination tub and shower, and wall-to-wall carpeting, and the hotel boasted a swimming pool, playground, laundromat, and 24-hour switchboard. The House of Hess Restaurant opened in 1969. Jim and Barbara Stipe managed these investments for entrepreneur-developer W. Dale Hess. The completion of Interstate 95 caused another business shift for Edgewood. Most travelers no longer took Route 40, so the motels and travel-oriented businesses on that route suffered, while new business opportunities flourished near Interstate 95. (Both, courtesy of Hess Hotel.)

The Anderson Feed Store, constructed in 1937, was owned and operated by S.H. Anderson and his brother Charles. Located south of Edgewood on Route 40, the store provided feed stock and supplies to farms and households in Edgewood, Joppa, Abingdon, and White Marsh. It also offered plumbing and heating services and sold and delivered propane tanks. The store provided churches and local fire companies with propane supplies without charge. (Courtesy of Anderson Hardware store.)

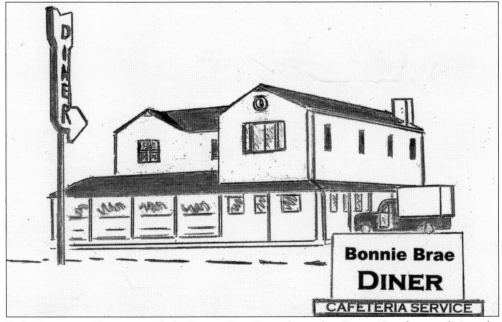

Before Interstate 95 was created, the Bonnie Brae Diner, located on Route 40 at the top of Magnolia Hill, was known as a great stop for those traveling north and south. With its cafeteria-style setup, it offered truckers and other patrons fast "no waiting" service, advertising that "quick turnover means you are assured of good fresh food at all times." (Courtesy of Joseph Murray.)

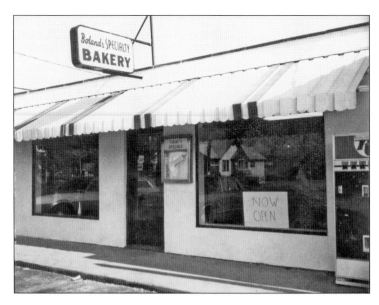

Boland's Specialty Bakery opened for business on November 18, 1972, and was located on the east side of Edgewood Road, behind the Edgewood Diner and beside Peltzer's sport shop. It advertised that it was "Edgewood's complete bakery," and its unique specialty was Bill Boland's "millionaire pie," the ingredients of which were kept under wraps. (Photograph by June Hanson; courtesy of HCPL.)

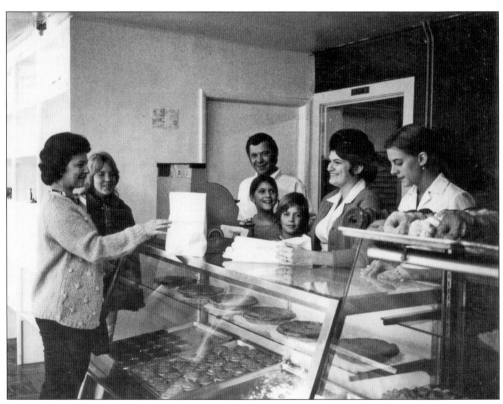

Some of Boland's customers on opening day were Sue Burkentine and her daughter, Terri. Behind the counter (from left to right) are Bill Boland, his children Lisa and Mark, his wife, Sue Boland, and Diane Meyers. Bill Boland graduated from the Baking School of Oklahoma State University. (Photograph by June Hanson; courtesy of HCPL.)

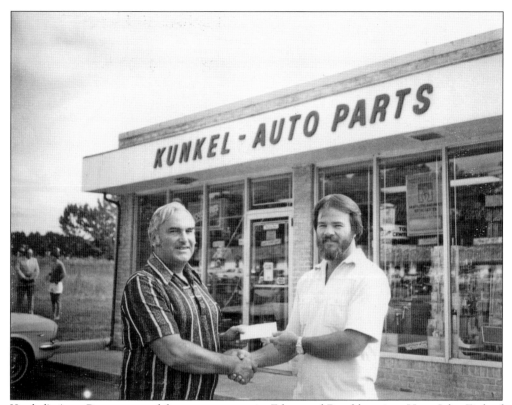

Kunkel's Auto Parts operated for many years at its Edgewood Road location. Here, John Fink of Kunkel's is presenting a check to Lynn Hershfeld (right) to sponsor the Pee Wee team in the 1979 Youth Football Program. (Photograph by Paul Yanney, Harford County Parks and Recreation; courtesy of HCPL.)

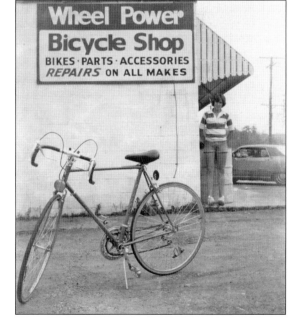

Wheel Power Bicycle Shop was located near the corner of Edgewood Road and Route 40. It carried many different sizes and models. Partner Bob McClellan reported that the shop could repair any bicycle if the parts were available. (Photograph by June Hanson; courtesy of HCPL.)

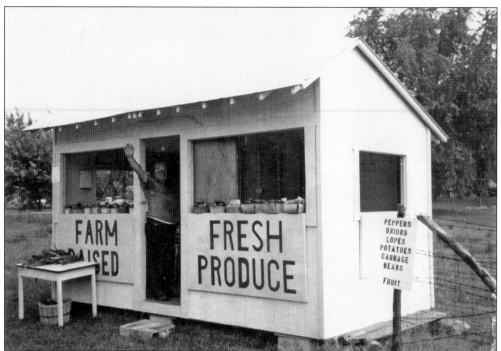

During the harvest season, Odis Graham ran a fresh fruit and produce stand that was located on Magnolia Road just north of the Trimble Road intersection. As seen in this 1973 photograph, he had a variety of vegetables for sale, most of which had been grown in his own garden. (Photograph by June Hanson; courtesy of HCPL.)

In September 1977, Edgewood residents Jan Grzanowski and Carol Aguilar opened Carol's Used Book Store in this building. In May 1979, the store moved to a double-wide modular building located just across Route 40 from this location. It proved to be a more modern and convenient location. (Photograph by June Hanson; courtesy of HCPL.)

The Edgewood Press, located on the corner of Edgewood Road and Pine Street, opened in July 1946. It was run by the Wise family and printed such things as wedding invitations, tickets, business cards, booklets, letterheads, envelopes, programs, and flyers. Here, in 1973, Al Wise operates a machine called the Little Giant Automatic Press. (Photograph by June Hanson; courtesy of HCPL.)

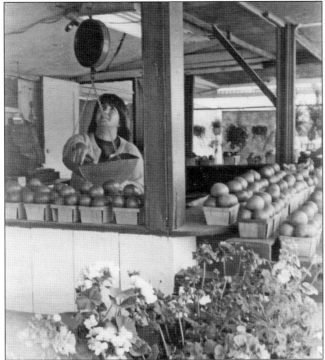

The Jones Produce Farm stand operated on Route 7 just west of Edgewood Road. Customers came daily throughout the spring, summer, and fall months to purchase a wide variety of fresh vegetables and ornamental flowers and shrubs. Shown here in 1978 is Joan Jones weighing a customer's purchase. (Photograph by June Hanson; courtesy of HCPL.)

The McComas family funeral business was first established in 1808 and has served the funeral needs of the Edgewood community for many years. This is the Howard K. McComas and Son Funeral Home, once located on Abingdon Road. The fencing was added in 1964, when the parking lot was extended. The large family home shown in the background was constructed in 1920. (Photograph by June Hanson; courtesy of HCPL.)

The Acme Supermarket was the anchor store of the Edgewood Shopping Plaza when it opened in the early 1960s. Acme closed its doors at this location in 1982. Santoni's grocery store occupied the building until it closed in 1998. Subsequently, Dollar General took over the space. (Photograph by June Hanson; courtesy of HCPL.)

The Windmill Nursery was just off Route 24 near Kennedy Highway (Interstate 95). It offered a wide range of plants, trees, and shrubs. In keeping with a name like Windmill, the garden center also sold wooden shoes that could be used for gardening. (Photograph by June Hanson; courtesy of HCPL.)

In 1976, the West Shore Indoor Tennis Club opened. Located at 2723 Pulaski Highway, the 20,000-square-foot building with a gold and bronze exterior had three regulation tennis courts. It was owned and operated by Nancy and Bruce Jacobs. The building later became the Maryland Sports Arena. The sign in the foreground advertised the future professional office building. (Photograph by June Hanson; courtesy of HCPL.)

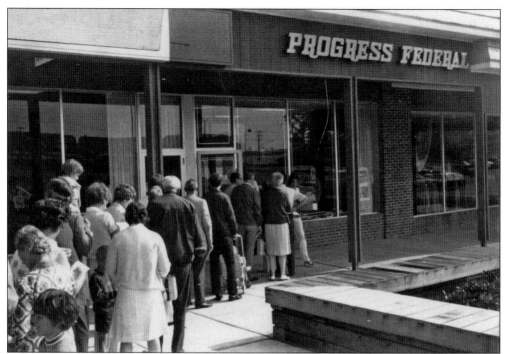

For its grand opening in July 1974, Progress Federal's Edgewood office offered a choice of 70 free gifts for anyone opening a new account. The type of gift depended on the level of initial deposit. The effective yield at the time on a $10,000 deposit was a 7.9 annual percentage rate. (Photograph by June Hanson; courtesy of HCPL.)

As part of its 1974 grand opening on Edgewood Road, the Commercial Savings Bank offered a grand prize of a new American Motors Gremlin. The bank building has subsequently served as home to a variety of entities, from a church to a tattoo parlor. (Photograph by June Hanson, courtesy of HCPL.)

American Hardware Store in the Edgewater Shopping Center carried a complete line of hardware as well as housewares, plumbing and electrical supplies, paint, and gardening tools. Shown here from left to right are manager Harold Paris, cashier Gerry Boynton, and owner Bob Feldman on opening day in February 1974. (Photograph by June Hanson; courtesy of HCPL.)

The Edgewood IGA store was located at the corner of Edgewood Road and Route 7. The store was run for a number of years by the Mossmiller family. Shown here, Lynn Hershfeld (left) accepts a donation from John Mossmiller on behalf of the Edgewood Recreation Council's Youth Football Program. (Photograph by Paul Yanney, Harford County Parks and Recreation; courtesy of HCPL).

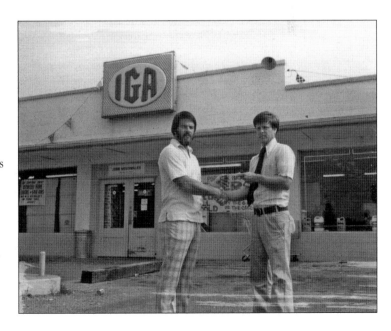

Tropical Exotics Pet Center, located in the Edgewater Shopping Center, opened in 1974. It offered a complete line of pet supplies, along with tropical fish and small animals, including mice, iguanas, guinea pigs, hamsters, gerbils, and snakes. The store was operated by Stewart Manuel (shown here) and his family. (Photograph by June Hanson; courtesy of HCPL.)

Rudolph Sorrentino opened Rudolph's Barber Shop in 1974. The shop was located in the Edgewater Shopping Center on Route 40 and offered styling for men, women, and children. Sorrentino's hair and attire were in the style of the day. Note the cash register. (Photograph by June Hanson; courtesy of HCPL.)

Six

RECREATION

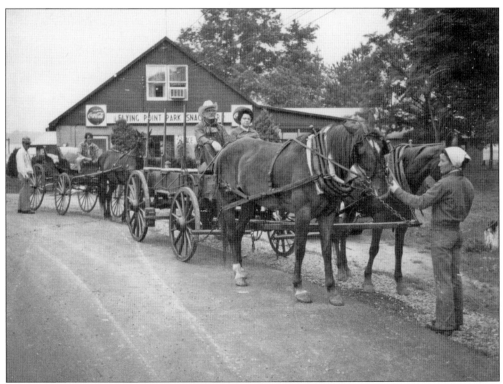

There were plenty of fun things to do in Edgewood in the 1960s and 1970s. Recreational outlets included a park with a beach, a marina, a motorcycle racetrack, soapbox derbies, model railroading, square dancing, a movie theater, roller-skating, swimming, and various clubs. As seen in the photograph, horse-and-buggy rides were featured at community picnics held at Flying Point Park. (Photograph by June Hanson; courtesy of HCPL.)

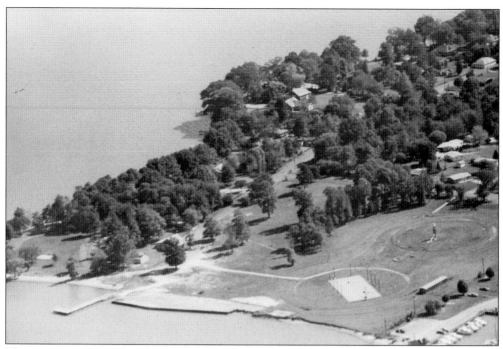

There is no agreement on how Flying Point Park, located off Willoughby Beach Road, got its name. One account suggests that the park derived its name from the point of land jutting out from its surroundings into the Bush River, while another surmises the name comes from the wedge-shaped formations of waterfowl that visited this area each year. (Photograph by June Hanson; courtesy of HCPL.)

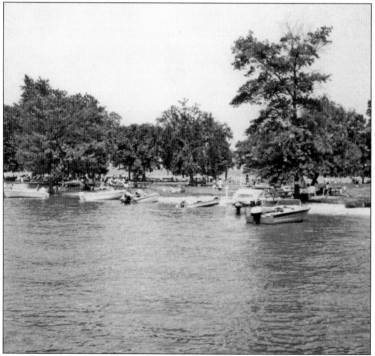

Flying Point Park was Harford County's first public beach. When it opened in 1967, it featured 1,850 feet of shore frontage on the Otter Point Creek, a boat-launching ramp, picnic tables, and a pavilion. People could arrive by boat. The gently sloping beach made it easy to land. Previously, a private fishing pier had been built on the property in the 1950s. (Photograph by June Hanson; courtesy of HCPL.)

The narrow-gauge scale model locomotive train provided years of enjoyment at Flying Point Park. Built in 1965, the train with two passenger cars circumnavigated the entire park. It ran for 20 years, was shut down in 1985, was stored in a shed for 10 years, and was restored by volunteers in 1995, but it was later sold by the county. The tracks were removed in 2002. (Photograph by June Hanson; courtesy of HCPL.)

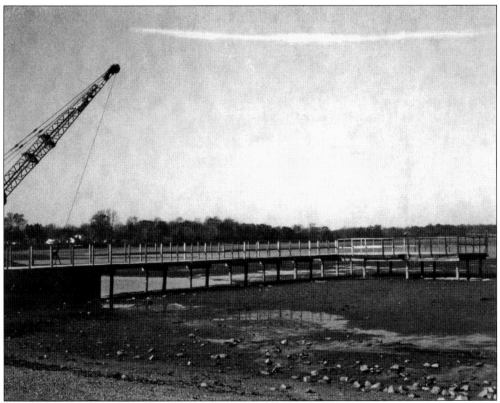

The launching dock at Flying Point Park was almost dry at low tide after a strong wind storm blew the water out of Otter Point Creek in the fall of 1974. It occurred while improvements were being made to the launch and pier areas. The crane was dredging down five feet to provide greater access for motorized boats. (Photograph by Paul Yanney, Harford County Parks and Recreation; courtesy of HCPL).

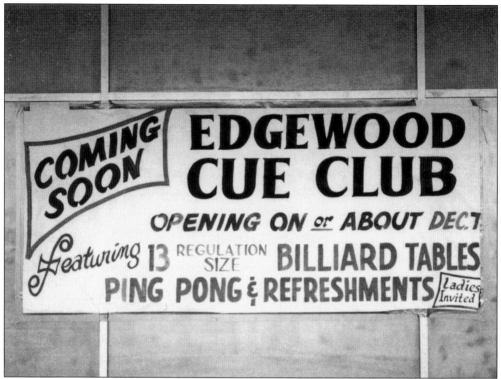

After a slight delay, the Cue Club opened in early 1973 in the Edgewood Shopping Center next to the Plaza Drugs store. The pool hall featured 13 regulation billiard tables. People could also play Ping Pong there. A special invitation was given to the ladies to come and enjoy the games. (Photograph by June Hanson; courtesy of HCPL.)

Flying Point Marina was originally known as Bauer's Trojan Harbor. In 1957, brothers Warren and Gordon Bauer used the dredge-and-fill method to construct the marina on Otter Point Creek near the entrance to the Bush River. They added a store, an office, and a repair shop, three boat sheds, and the Trojan Harbor Yacht Club. Bauer's Trojan Harbor store was akin to a small convenience store. (Courtesy of Joseph Murray.)

The Trojan Harbor Yacht Club hosted numerous events, such as "all you can eat" shrimp and crab feasts, dances, and New Year's Eve parties. The club did not have a liquor license but operated as a private club. It had lockers where individuals could store their own bottles of liquor. (Courtesy of D.J. Gilfert.)

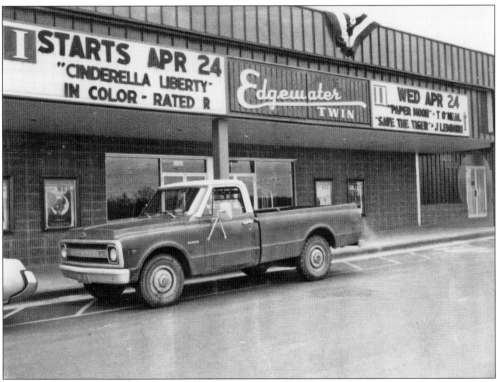

Edgewood Twin Theaters opened on April 24, 1974. It was located in the Edgewater Shopping Center. *Cinderella Liberty* was playing at one screen, and *Save the Tiger* and *Paper Moon* were playing at the other. The congregation of Prince of Peace Catholic Church used the theater for its services during its earliest days. (Photograph by June Hanson; courtesy of HCPL.)

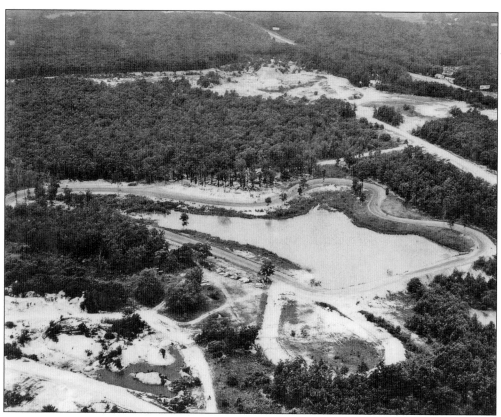

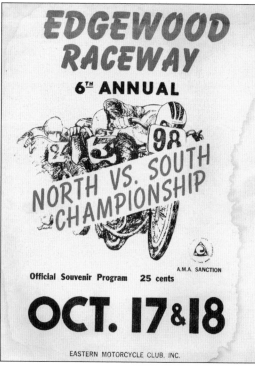

During the 1960s, the Edgewood Raceway was considered the best motorcycle course of its kind on the East Coast. Godfrey Larry "G.L." Stancill, who had operated a sand and gravel business at this location, built the legendary track. The hard clay base course was seven-eighths of a mile long, with a scenic spring-fed pond (now known as Lake Serene) in the center. (Courtesy of Tim Stancill.)

Eight annual North-South championship motorcycle races were held at the Edgewood Raceway. The 1967 North-South TT Motorcycle Championship races had 460 entries, and almost 5,000 spectators watched the events. The starting line could handle up to 14 motorcycles abreast, and 60 riders could be on the track at one time. The lake in the center was 18 feet deep, and swimming was permitted. (Courtesy of Tim Stancill.)

NATIONAL TT SCRAMBLE CHAMPIONSHIP

EDGEWOOD RACEWAY
EDGEWOOD, MD.

AMA Sanctioned

Camping Area

SEPTEMBER 15-16, 1962

PRACTICE — SEPT. 12-14

First Aid & Ambulance in Attendance.

GIGANTIC TROPHIES

7 CLASSES

For Entry Blanks
Stancil, Inc.
Box 727
Edgewood, Md.

RAIN OR SHINE

Promoted by
Iron Pony
Motorcycle Club

The first National TT Scramble Championship race held in the country was run in September 1962 with 350 entries. The Iron Ponies motorcycle club of Edgewood sponsored the race on a course that *Cycle Sport* magazine described as "probably the most spectacular and popular one of its kind anywhere in the East." (Courtesy of Tim Stancill.)

The Baltimore Symphony Orchestra gave two concerts each year at the Edgewood High School auditorium in the 1970s, thanks to federal, state, and county grants. The purpose of the grants was to give local residents the opportunity to experience excellent music close to home. (Photograph by June Hanson; courtesy of HCPL.)

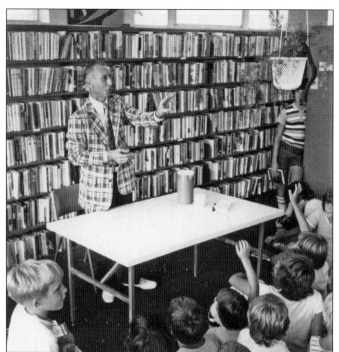

Approximately 200 boys and girls came to the Edgewood Library in August 1976 to talk with Cal Ripken Sr., the Baltimore Orioles' bullpen coach. Ripken was a beloved and respected figure long before his son (Cal Jr.) became a hall-of-fame player for the Orioles. The children had lots of questions for him. (Photograph by June Hanson; courtesy of HCPL.)

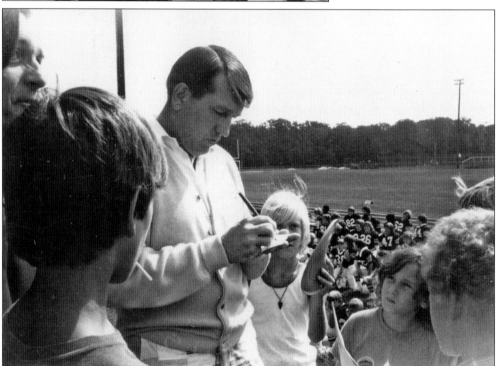

Johnny Unitas, legendary hall-of-fame quarterback for the Baltimore Colts, was a special guest of honor at the opening ceremony of the Edgewood Recreation Council Youth Football Program in the fall of 1979. He obligingly signed autographs for all who asked. (Photograph by June Hanson; courtesy of HCPL.)

The Harford Golf Center and Family Sports Park, located at 2500 Pulaski Highway (Route 40), opened in March 1974. It featured two miniature golf courses, a golf driving range, tennis and baseball practice cages, and a large picnic area. It was in a low-lying area that was susceptible to flooding. This area is now all marshland. (Photograph by June Hanson; courtesy of HCPL.)

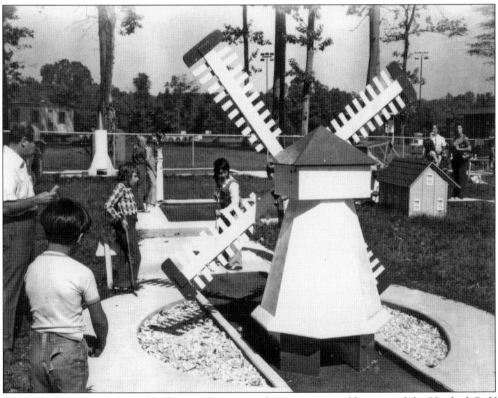

The hole featuring the windmill was a favorite at the miniature golf course of the Harford Golf Center. A round of miniature golf cost 75¢. The center sponsored "Champion of the Course" competitions for various age groups. A number of fundraising events were held here. (Photograph by June Hanson; courtesy of HCPL.)

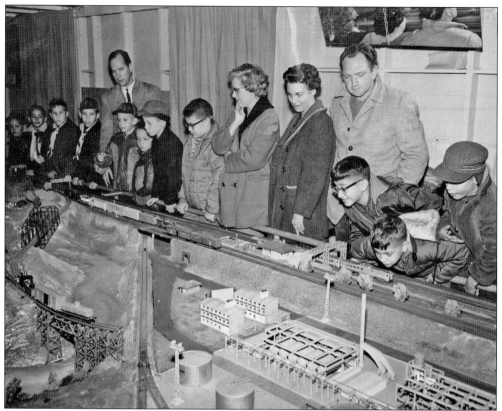

Since it was started in 1955, thousands of people have enjoyed seeing the extensive displays created by the Edgewood Area Model Railroad Club, especially at the annual open houses in December. Visitors included various school and Scout groups and other model railroad organizations. People of all ages have found the model railroad fascinating. One such group is seen in this 1963 photograph. (Courtesy of Aberdeen Proving Ground–Edgewood Area Public Affairs Office.)

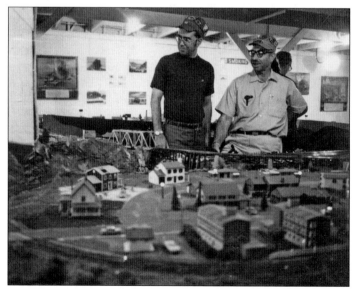

At a 1972 exhibit, David Renard (left) and Robert de Leeuw, original members of the Edgewood Arsenal Model Railroad Club, operated the control boards in the large layout. Each year, club members added to the display. By 1987, it had eight trains running on 1,300 feet of track. A 1987 Maryland guidebook called the club's display "elaborate" and "one of the oldest in the country." (Photograph by June Hanson; courtesy of HCPL.)

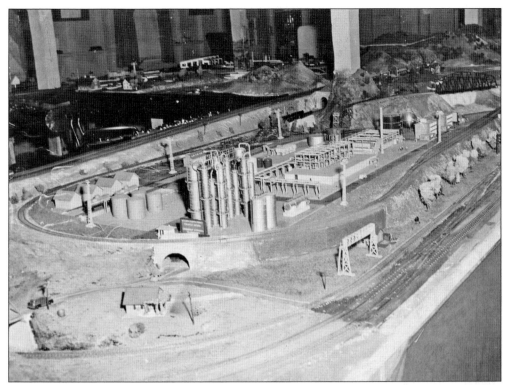

From the beginning, the Edgewood Area Model Railroad Club began creating a permanent layout of realistic scenes. Club members handcrafted numerous miniature structures, as seen in this 1958 photograph. In 2000, the old wooden barrack that had housed the club's display for 45 years needed to be torn down. At its new location, the club started to build an entirely different display. (Courtesy of Aberdeen Proving Ground–Edgewood Area Public Affairs Office.)

Over the years, the Lions Club of Edgewood has been involved in sponsoring various recreational and sports activities for the younger generation. Henry Hein is seen here wearing his Edgewood Lions uniform in the early 1950s. (Courtesy of Henry R. Hein.)

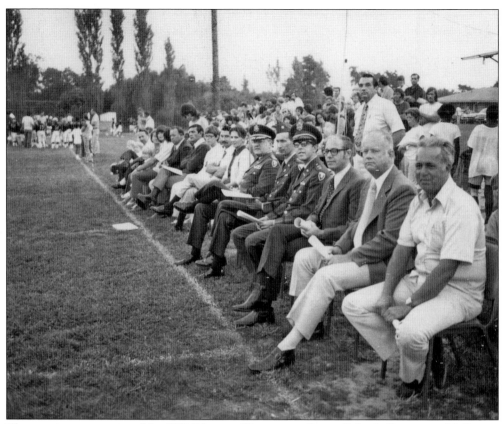

The opening ceremonies of the 1973 Edgewood Recreation Council's football season at McComas Field included a number of honored guests. Among the officials in attendance were the Harford County executive, the commanding officer at Edgewood Arsenal, the principal of Edgewood High School, a Maryland State Police commander, and the director of the county's parks and recreation. (Photograph by June Hanson; courtesy of HCPL.)

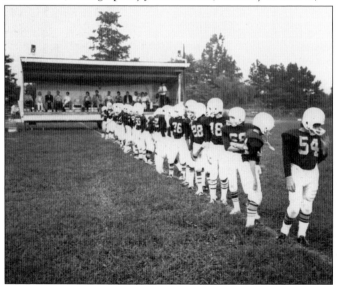

These are the 1975 Big Macs of the Junior Midget Division of Edgewood Recreation Council's football program. They were sponsored by McDonald's. Other teams were sponsored by Edgewood Phillips 66, B&H Electric, Edgewood Lions, and Harford Sands. (Photograph by June Hanson; courtesy of HCPL.)

In July 1973, some members of the Starlight Arena's competitive roller-skating team posed for photographs before a regional competition. They are, from left to right, Robin Cornelius, Bill Pulner, Kit Tyson, Mike Hucks, and Mary Gosnell. The arena was used for recreational as well as competitive roller-skating. (Photograph by June Hanson; courtesy of HCPL.)

The Fair Lanes bowling alley opened in 1972. Located atop a hill along Route 40, it was run by Jim Self and featured 32 lanes. The facility attracted people of all ages, whether as part of a league or as individual bowlers. (Photograph by June Hanson; courtesy of HCPL.)

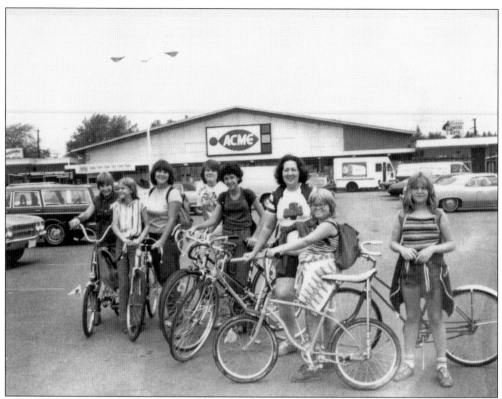

In September 1979, Girl Scouts and leaders of Cadette Troop 863 took a bicycle trip to Skipper's Point. They started from the Acme parking lot on Hanson Road. They are, from left to right, Daniella Appelt, Kim Hicks, Barbara Zvirblis, Kira Smith, Sidea McKaughan, leader Helen Sherman, Jeanie Smith, and Cathy Sherman (Junior Scout). (Photograph by June Hanson; courtesy of HCPL.)

Members of Edgewood Cub Scout Pack 804 added the 1974 Scout-O-Sphere Award of Merit and Honor to their Pack flag. They received this award during an event held in Timonium, Maryland. The pack met once a month at the Cedar Drive Elementary School. (Photograph by Paul Yanney, Harford County Parks and Recreation; courtesy of HCPL.)

The Lions Club has sponsored a number of events over the years to raise funds for its works within the community. For example, club members and their wives have held their annual Spring Carnival. In 1976, the carnival was held in the Ames parking lot. There was plenty of food and rides for people of all ages. (Photograph by June Hanson; courtesy of HCPL.)

Before the King's Brothers three-ring circus started, people were invited into the zoo and side show to see the animals and a puppet show. The woman on stage in costume was the elephant trainer, and with her was Checkers the Clown. The circus had been brought to town by the Edgewood Century Lions Club in 1972. (Photograph by June Hanson; courtesy of HCPL.)

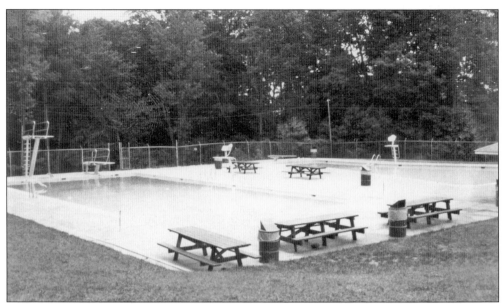

The Edgewood Meadows Swim Club was located on Hanson Road just beyond the Edgewood Plaza and the current Edgewood Post Office, in what is now a vacant lot. It had two large pools (35 feet by 75 feet) and a wading pool. It also had playground equipment. In 1977, it was taken over by the YWCA and subsequently closed. (Photograph by June Hanson; courtesy of HCPL.)

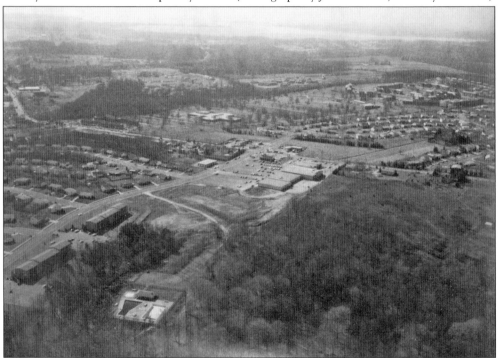

The Edgewood Meadows pool, seen at the bottom of this 1973 aerial photograph, was open to anyone, not just Edgewood Meadows residents. With the Gunpowder River on the horizon and Hanson Road running diagonally from the lower left, the library and Edgewood Shopping Plaza are among the recognizable features. (Photograph by June Hanson; courtesy of HCPL.)

All entries for the third annual Soap Box Derby (1978) had to be inspected before they raced down Box Elder Drive in Edgewood Meadows. The Boy Scouts sponsored the races. In the middle school's parking lot, from left to right, David Collins sits in his No. 7 car as race coordinator Frank VanNostrand inspects it. Checking Mark VanNostrand's vehicle are scoutmaster Bob Rinker and official inspection coordinator Dan Morrison. (Photograph by June Hanson; courtesy of HCPL.)

In April 1979, a Cystic Fibrosis Bike-a-thon was held. Participants had sponsors who pledged money for each mile they traveled. The riders circled the Edgewood Elementary School over and over again to accumulate the miles. (Photograph by June Hanson; courtesy of HCPL.)

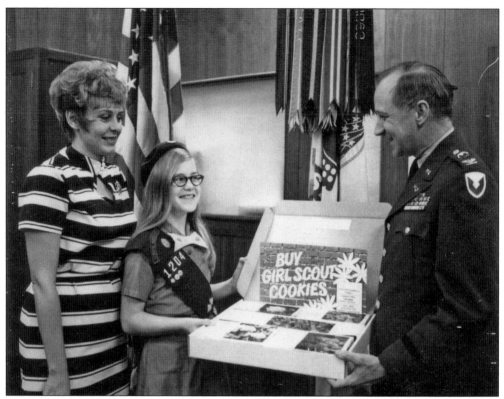

Edgewood community cookie chair Ann Feehey and Junior Girl Scout Virginia Boyd showed the 1973 selection of Girl Scout cookies to Col. John K. Stoner, commanding officer of Edgewood Arsenal. The Girl Scouts took orders for cookies and set up sales at the Edgewood Ames and Acme stores and in front of the arsenal's commissary and post exchange to help support their local council. (Photograph by June Hanson; courtesy of HCPL.)

In September 1981, the gym and library of the former Edgewood Elementary School became the site for the Youth Community Center. The Boys and Girls Club of Harford County found the facility to be in such poor condition that it raised funds and built the current Boys and Girls Club of Edgewood at this location. (Photograph by June Hanson; courtesy of HCPL.)

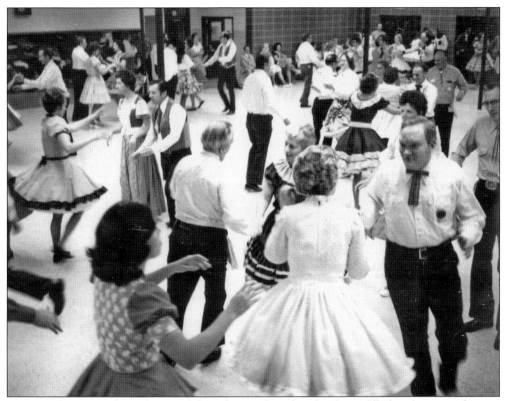

In December 1976, the cafeteria of the Edgewood High School was filled with square dancers from all over the Baltimore area for the Square Dancer Callers' annual dance. Edgewood's Yellow Rockers hosted the event. It was the first time the event was held in Harford County. (Photograph by June Hanson; courtesy of HCPL.)

The Edgewood Golden Age Club celebrated an "Everybody's Birthday Party" for all of its members at this May 1972 event held at the Trojan Harbor Yacht Club. This was just some of the club members participating. Potential members had to be over age 55 to join the club. Among the other things the club did for enjoyment that year was to take a bus tour to Hershey, Pennsylvania. (Photograph by June Hanson; courtesy of HCPL.)

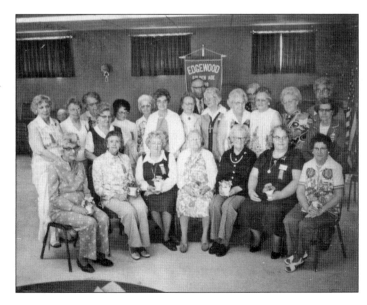

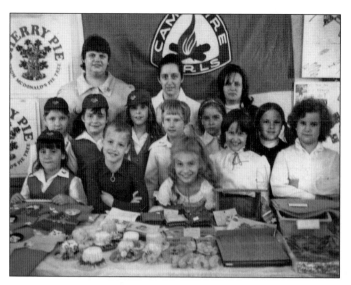

The Edgewood Camp Fire Girls provided a fun and nurturing place for young girls. Shown in this 1973 photograph are, from left to right: Linda Billings, Kathy Daw, Diana Harris, Kris Kusma, Aguste Whitworth, Ginny Kidwell, Angie LaRosa, Annette Harper, Donna Medley, Melissa Tarbet, and Laurie Ambrose. Leaders Lennis Hogner, Polly Shunk, and Jean Medley are in the back row, from left to right. (Photograph by June Hanson; courtesy of HCPL.)

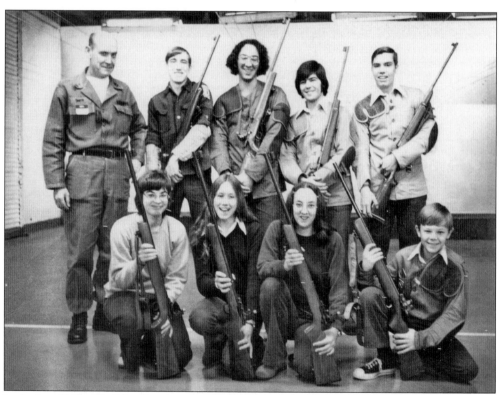

In the late 1960s, Sfc. John Smith, a member of the 1956 US Olympic Rifle Team, started a youth rifle team at the arsenal. Seen in this 1974 photograph are, from left to right, (kneeling) Diane Gordon, Pat Newcomb, Liza Kauzlarich, and Sergeant Smith's son, Dean; (standing) Smith, Rob Newcomb, Mike Kauzlarich, Al Ciofi, and Steve Breining. (Photograph by June Hanson; courtesy of HCPL.)

Two children from Edgewood, Andre Joyner and Margaret "Maggie" Stuempfle, were selected to help Pres. George W. Bush and First Lady Laura Bush push the button to light the 13,000 colorful lights of the 2003 National Christmas Tree at the Pageant of Peace in Washington, DC. The lighting ceremony was broadcast on television across the country. The children represented the Edgewood branch of the Boys and Girls Club of Harford County and were chosen by the White House staff because of their outstanding participation as club members and their winning essays. The word "Eagles" in the photograph below refers to the Edgewood Elementary School Eagles. These photographs capture a truly unique part of Edgewood's history and the future possibilities for Edgewood children to make history. (Above, courtesy of George W. Bush Presidential Library; below, courtesy of Amy Stuempfle.)

DISCOVER THOUSANDS OF LOCAL HISTORY BOOKS FEATURING MILLIONS OF VINTAGE IMAGES

Arcadia Publishing, the leading local history publisher in the United States, is committed to making history accessible and meaningful through publishing books that celebrate and preserve the heritage of America's people and places.

Find more books like this at
www.arcadiapublishing.com

Search for your hometown history, your old stomping grounds, and even your favorite sports team.